MONTEREY POP

.

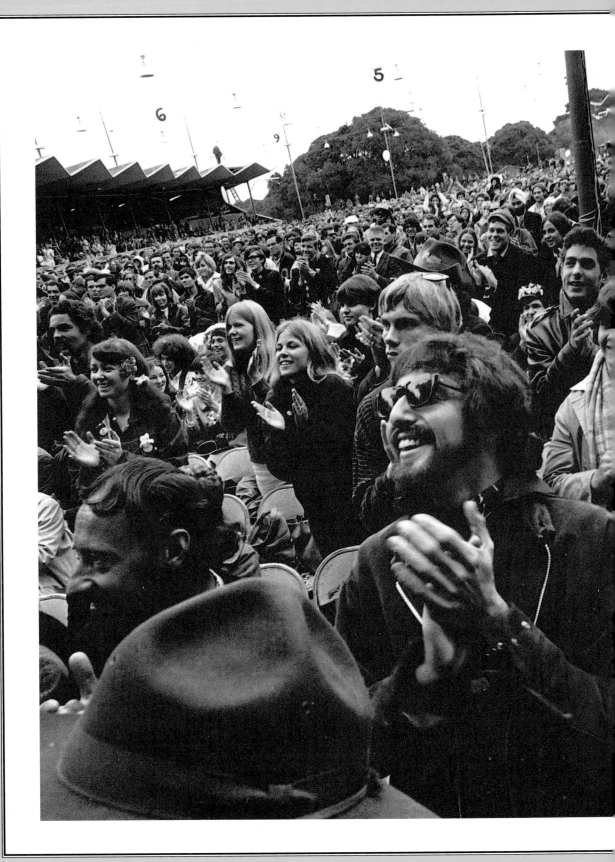

MONTEREY POP

....................

JUNE 16 - 18, 1967

by Joel Selvin

PHOTOGRAPHS BY
Jim Marshall

CHRONICLE BOOKS · SAN FRANCISCO

Text copyright © 1992 by Joel Selvin

Photography copyright © 1992
by Jim Marshall

Book design: John Sullivan &
Dennis Gallagher, Visual Strategies,
San Francisco

Printed in Hong Kong

Library of Congress
Cataloging-in-Publication Data

Selvin, Joel.

Monterey Pop : June 16-18, 1967 /
by Joel Selvin ; photographs by
Jim Marshall.

p. cm.

ISBN 0-8118-0153-5

1. Monterey International Pop
Festival (1967 ; Monterey, Calif.)
I. Title.
ML3534.S44 1992
781.66'078'79476—dc20 91-30477

CIP

MN

Distributed in Canada by Raincoast
Books, 112 East Third Avenue,
Vancouver, B.C. V5T 1C8

10 9 8 7 6 5 4 3 2 1

Chronicle Books
275 Fifth Street
San Francisco, CA 94103

Contents

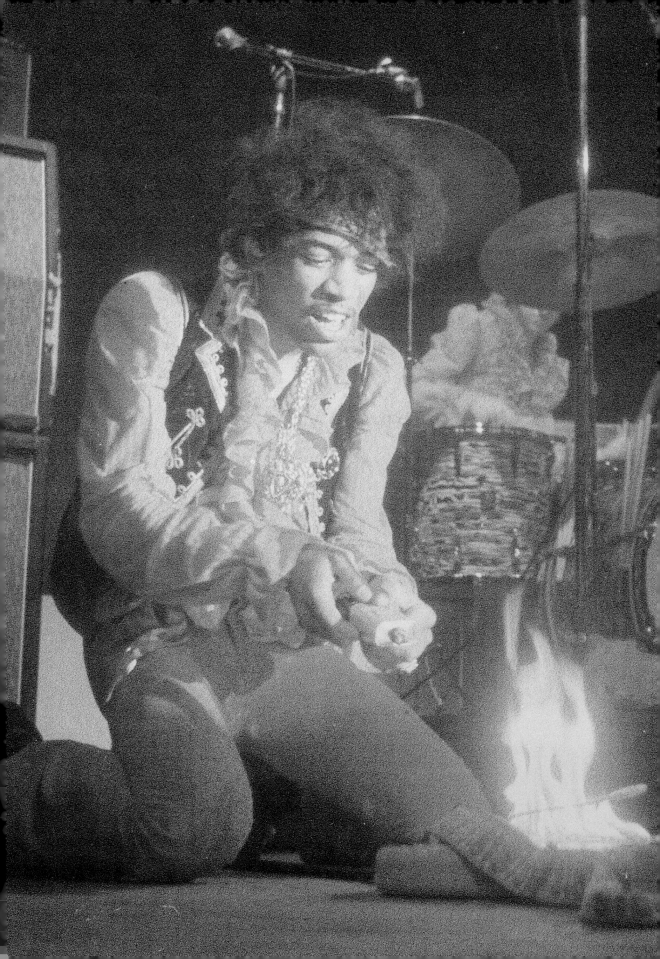

Introduction

"PEOPLE SAY ABOUT US how we couldn't make it here, so we go to England and America doesn't like us 'cause our feet's too big, we got fat mattresses and wear golden underwear. Ain't no scene like that, brother. Dig, man, I was laying around and I just went to England and picked up these two cats. It was so groovy to come back this way and really get a chance to play. I COULD SIT UP HERE all night and say thank you, thank you, thank you. I wish I could just grab you, man, and just . . . (lips smacking) . . . one of them things, one of those scenes. But, dig, I just can't do that. SO WHAT I'M GONNA DO, I'm gonna sacrifice something that I really love — thank you very much for Bob Dylan's grandmother. Don't think I'm silly doing this, y'know, 'cause I don't think I'm losing my mind. Last night, man, oooh God . . . (laughs) . . . wait-wait-wait-a-minute. But today I think it's the right thing, all right. So I'm not losing my mind. This is for everybody here. This is the only way I can do it. So we're gonna do the English and American combined anthem together. Don't get mad. No-o-o-o-o. Don't get mad. I want everybody to join in, too, all right? Don't get mad. This is it. There's nothing I can do more than this. Oooh, look at those beautiful people out there."

A REVERBERATING HUM FILLS THE ARENA, AND A SHOCK OF SHRILL FEEDBACK PIERCES the rumble. As he points the guitar straight down, the shriek turns to a whooshing roar that rises into a billowing balloon of pure sound. A couple of tweaks on the tremolo bar interrupt the cascading sonic blur, which resumes its rampage into a machine-gun rattle, settling into a single pinpoint of sound and then, silence. He gives the strings a couple of casual strokes, surprisingly gentle, and then comes down hard into the chunky opening chords of "Wild Thing," the Troggs' garage-rock grunge that was an instant classic on its release the previous year—in his words, "the English and American combined anthem."

He toys with the vocals, popping his tongue against the roof of his mouth to punctuate the stop-break into the chorus, and speaks-sings the lyrics with an offhand informality quite at odds with the havoc he is wreaking with the guitar. He pauses in the instrumental break to toss off pieces of the melody of "Strangers in the Night," as unlikely a place for a musical reference to Frank Sinatra as any imaginable. He rolls across the stage in a somersault, still playing, and resumes singing, holding the guitar behind his back, still playing.

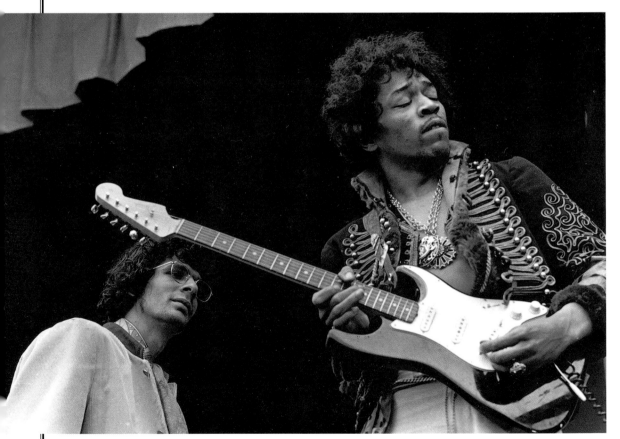

Assistant stage manager Al Kooper watches some unknown guitarist play the sound check.

Nothing less than everything he could give would do. Tonight, it would not be enough to simply satisfy the crowd. They must be devastated. They must be destroyed. All that came before must be obliterated in their minds.

After one more chorus, he presses his guitar up against his stack of amplifiers, feedback screaming, and dry-humps the back of the guitar. He slips out of the strap and drops to his knees, the guitar flat on the stage, and sprays lighter fluid over the face of the instrument. Bending down, he gives the guitar one quick kiss goodbye and ignites the fluid. Flames dance in front of him. His fingers flutter encouragement. He grabs the flaming Fender by the neck and breaks it apart on the stage, swinging it wildly. The pieces are discarded — burnt offerings — into the audience as he staggers off the stage and into history. Jimi Hendrix has played the Monterey Pop Festival.

No single performance has been more deeply embedded into the firmament of rock than Hendrix at Monterey. At the U.S. debut of his British-formed group, the Jimi Hendrix Experience, he walked onstage a nobody and walked off a major star, ready to rewrite the language of the guitar. The penultimate performer — the Mamas and Papas would follow him to close the show in an indifferent performance few but the principals remember — Hendrix was not alone in leaving the festival grounds having established a worldwide reputation. With a single stroke, others also achieved fame: Otis Redding, Janis Joplin, The Who.

The Monterey International Pop Festival would happen only once, June 16–18, 1967. And it happened rather quietly amidst the cypress trees, fog, and sand dunes that surround Monterey, a sleepy oceanside city lying less than halfway from San Francisco to Los Angeles. Away from the mass media and prying electronic eyes, perhaps as many as 50,000 young pilgrims came to witness a historic confluence of talent. The festival straddled the shifting values of the time, simultaneously sounding the death knell to Top Forty and ringing the ascendancy of a more vigorous rock music that emerged from the underground at Monterey.

Produced by Hollywood music business professionals, the Monterey International Pop Festival turned to London and San Francisco for bold, daring sounds that would shake the world and mark the festival in history. While the British contingent happily gave the festival an international outlook, the tenuous accord between San Francisco and Los Angeles factions brought an underlying current of tension that ran from the festival's earliest planning stages right up to its final moments.

Monterey caught not only people, but the world in motion. The record industry standard was changing from a seven-inch 45 RPM record with a big hole in the center to a twelve-inch, long-playing album with a small hole. In San Francisco, the crucible forging so many of these changes, former Top Forty disc jockey Tom Donahue, had assembled a staff of hip young broadcasters and taken over a foreign language station on the FM dial, KMPX.

Rock royalty: Michelle Phillips

No longer playing quick, simple hit singles, these deejays were spinning lengthy album cuts — everything from Indian ragas to sinewy folk music, acid-rock jams to imported English rock albums — an innovation that would have far-reaching ramifications for many of the acts appearing at Monterey. Truly a watershed event in the history of pop music, Monterey heralded the arrival of gut-wrenching, blues-fired performers like Joplin, Hendrix, The Who, and Otis Redding. It also bid farewell to saccharine commercial acts such as the Association, Johnny Rivers, and, ironically, the Mamas and Papas themselves.

Monterey turned out to be a proving ground. The performers came to make their statements, not their careers. Nevertheless, many powerful people in the music industry experienced the new music for the first time at Monterey. Sensing a killing to be made, some of the sharks moved in on the spot that weekend. At the very least, these movers and shakers of the established order left Monterey with a glimpse of a new world.

The Monterey International Pop Festival was not only an unprecedented and unmatched collection of talent, the three-day event was also an axis on which the world of rock music turned. Music would never be the same again.

Over that weekend, the Monterey Pop Festival managed to simultaneously sum up and accelerate the dramatic changes sweeping through pop music. It was a festival taking place on the cusp of innocence. Never again would rock music be the charmingly uncorrupted force it was at Monterey. But, for one weekend at least, rock music was everything it was supposed to be: music, love, and flowers.

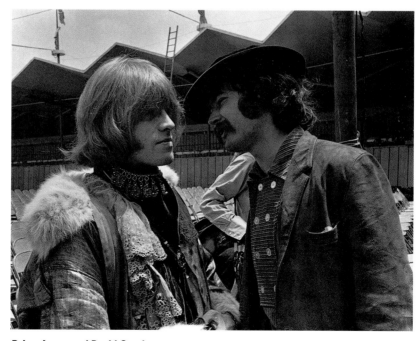

Brian Jones and David Crosby.

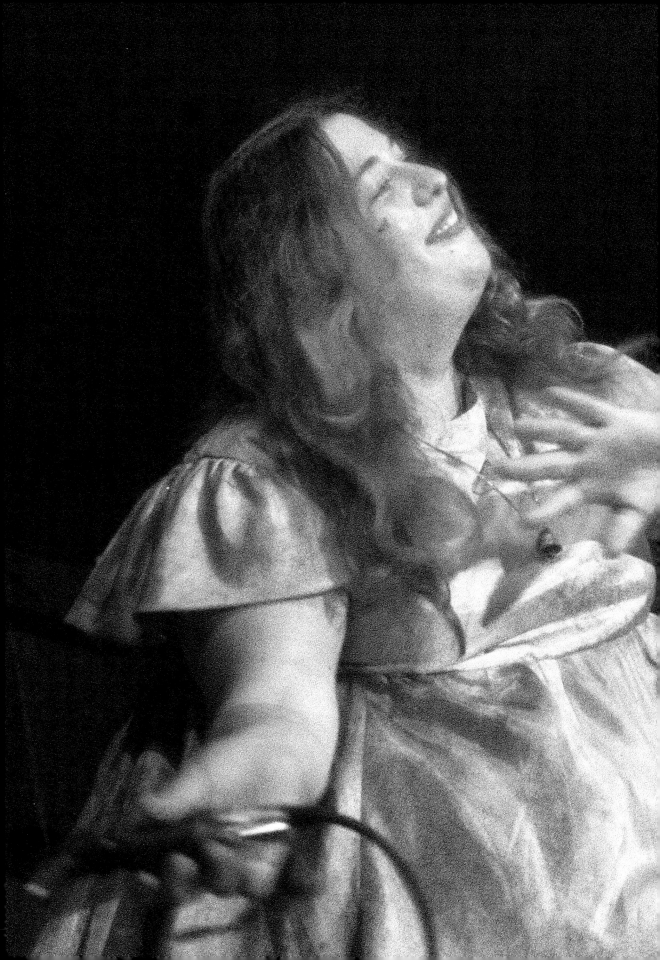

The Beginnings

· · · · · · · · · · · · · · · · ·

JANUARY
TO MAY, 1967

ONE HOLLYWOOD SCENESTER had seen Alan Pariser standing on the Sunset Strip sidewalk outside the Whisky-a-Go-Go with club owner Elmer Valentine so often, he thought that it was Pariser's office. Michelle Phillips and others remembered Pariser for his "Ice-Bag" marijuana, so named because it came in insulated ice bags, some of the first connoisseur-quality pot to hit the scene. Jefferson Airplane even named their song-publishing company "Ice Bag" in honor of his weed.

John Phillips

THIS HIPSTER-ABOUT-TOWN AND HEIR to the Sweetheart paper fortune produced his first concert in the fall of 1966 with the Byrds, the Doors, Hugh Masekela, Buffalo Springfield and Peter, Paul and Mary. The CAFF concert was a benefit to raise bail money for people arrested during the Sunset Strip riots that had inspired Stephen Stills of the Springfield to write "For What It's Worth."

Pariser attended the Monterey Jazz Festival that summer. The prestigious jazz fest had been launched in 1958, using the Monterey County Fairgrounds as the stage site, by jazz disc jockey Jimmy Lyons. His first budget was $6,700. With it Lyons presented Louis Armstrong, Billie Holiday, Dizzy Gillespie, Dave Brubeck, Harry James, Sonny Rollins, the Modern Jazz Quartet, and others. The annual event soon earned a national reputation, and crowds flocked from all over the West for the pastoral fall weekend.

Bouyed by the success of the CAFF, concert, where many of the musicians jammed together in a free-for-all finale, Pariser envisioned a full-blown pop festival along the lines of the established jazz festival. He took the idea to a few record companies around town, where he found the interest cool. Someone suggested he talk with Benny Shapiro, a hipster from an

Bigwigs backstage: Manager Albert Grossman and Bill Graham of the Fillmore.

earlier era with vast experience in the music business.

As a booking agent, Shapiro had finagled a spot for the young Bob Dylan in the short-lived Monterey Folk Festival in 1963. He represented acts as diverse as Peter, Paul and Mary and Ravi Shankar. Shapiro was also famous for parties in his Mediterranean-style villa in the Hollywood hills. As agent for Miles Davis and other jazz artists, Shapiro intimately knew the Monterey Jazz Festival. And, as producer of the soundtrack album for a quickie, hippie-exploitation movie called *Revolution*, Shapiro had also worked with such San Francisco–based rock bands as Quicksilver Messenger Service, the Steve Miller Blues Band, and Mother Earth, so he was also acquainted with the new rock sound growing outside the established Hollywood record industry.

One day early in 1967, Pariser happened to drive by the Continental House, a Sunset Boulevard hotel owned by cowboy star Gene Autry and see Shapiro on the street. They drove to Shapiro's house above Sunset where they forged a partnership to produce what would become the Monterey Pop Festival. Pariser raised $50,000 as seed money, using his own funds; money from his mother and sister; from Harry Cohn, Jr. (son of the onetime stu-

dio chief at 20th Century Fox); and from Bill Graham of the Fillmore Auditorium in San Francisco, who also managed the Jefferson Airplane.

Over a breakfast at Shapiro's home, they coaxed press agent Derek Taylor out of self-imposed retirement with the hardly grand but acceptable sum of $250 a week. Taylor, the stylish former Fleet Street reporter who accompanied the Beatles to America, had settled in Los Angeles where he represented clients such as the Byrds, the Beach Boys, and Paul Revere and the Raiders. He was also the father of four children, with a fifth on the way, who had recently "dropped out," the fashion in certain quarters at the time.

Through his friend David Wheeler, Pariser met graphic artist Tom Wilkes who designed a festival logo—a woodcut of Pan blowing on his pipes—stationery, advertising, and posters. A deposit reserved the Monterey County Fairgrounds. An office was set up in Shapiro's former Renaissance Club at 8428 Sunset Boulevard, across from the Continental House, and Pariser and Shapiro began to contact bands. They lined up the Airplane, the Byrds, Buffalo Springfield, Quicksilver, the Grateful Dead, and Ravi Shankar.

Photographer and filmmaker Barry Feinstein, married at the time to Mary Travers of Peter, Paul and Mary, put them in touch with manager Albert Grossman, who agreed to supply not only the Paul Butterfield Blues Band but also a new band, as yet unnamed, founded by former Butterfield lead guitarist Mike Bloomfield. Feinstein also hooked up the producers with stage manager Chip Monck, another Peter, Paul and Mary associate.

Derek Taylor phoned London to talk with his old boss, Paul McCartney, who suggested The Who and Jimi Hendrix for the fest. After three months, plans were under way, but moving slowly. What the festival needed most of all was headline acts. The most obvious choice among existing Los Angeles groups was uncontestably the Mamas and Papas, red-hot off of six consecutive Top Ten records and commanding consistent five-figure fees for concert appearances. Pariser, his friend David Wheeler, and Taylor went to visit John and Michelle Phillips of the Mamas and Papas. The two lived like rock royalty in a sumptuous Beverly Hills mansion on five acres occupied at one time by film star Jeanette MacDonald.

Pariser was riding for a fall and didn't know it. Soon the plans and the principals of the Monterey Pop Festival would be drastically altered. Something that began as a relatively simple idea grew more complex and ambitious than anyone could have imagined. And what was to end as a weekend of peace and love started out with back-stabbing and infighting.

Pariser and filmmaker Barry Feinstein had visited John Phillips in his Tudor mansion at 783 Bel Air Road the previous year to talk with him about Feinstein's film, *You Are What You Eat*. Phillips and his wife were living a grand life—Rolls Royces, furs, drugs, wild parties—and the group, despite continuing success, was beginning to show wear and tear. Cass Elliott, for instance, was pregnant and preparing for the life of a single mother rather than

paying much attention to the career of the Mamas and Papas. Pariser made a reasonable offer to obtain the group's services, but Phillips held off from making any commitment.

Something about the festival idea appealed to Phillips, and he discussed the possibilities with his producer, friend, and business partner, Lou Adler, a savvy, seasoned hand in the Hollywood record business. A Jewish scrapper from one of Los Angeles' Mexican neighborhoods, Adler and his partner Herb Alpert had written songs for Sam Cooke and had also managed Jan and Dean. After splitting with Alpert, Adler produced a string of hits by Johnny Rivers. He was married to actress Shelley Fabares of TV's "The Donna Reed Show," a saucy starlet who had also played in three Elvis Presley movies. He had borrowed a small sum from ABC Records in 1964 in exchange for the distribution rights to Dunhill Records, the record label he formed with the money. He sold the company back to ABC two years, many hits, and several million dollars later.

Adler had produced the 1965 hit by Barry McGuire, "Eve of Destruction," on Dunhill. While recording the follow-up album, he had let McGuire record a song by an old friend from their folk music days. McGuire had even brought the friend and his singing group into the studio to sing the background vocals on the track. Instantly impressed with the sound, Adler had erased McGuire's lead vocal and re-recorded a new vocal by his friend's group. "California Dreamin'" became the first hit by the Mamas and the Papas.

Both Adler and Phillips sensed the possibilities of Pariser's pop festival. They were members of a young elite, riding the wave of a surging art form, already vastly influential but still, in many ways, under-appreciated. Adler had discussed the issue with Paul McCartney one night only weeks earlier at Mama Cass' house. Monterey offered an irresistible forum to demonstrate the persuasive power of rock music and the burgeoning creativity in the field. They had to take the reins.

Phillips hit on the idea of making the festival a charity fund-raiser for some as-yet-unnamed charity and having the acts play free. Paul Simon and Art Garfunkel, staying in town at the Beverly Wilshire Hotel, were enlisted for support.

Adler had known Benny Shapiro as an agent with William Morris who booked a few dates for Jan and Dean many years before. Shapiro had no interest in producing the festival for charity, so Adler, Phillips, and their lawyer, Abe Somer, who had started out representing Pariser and Shapiro, cut Shapiro out of the picture. Phillips and Adler became co-directors of the event; Pariser was reduced to co-producer with Mamas and Papas road manager Peter Pilafian. The coup was complete.

Shapiro was gone, sent away with hurt feelings and a substantial settlement. He would later blast what he called the festival's new "Top Forty" concept in the press. Fewer than ninety days remained before the event.

Adler and Phillips tapped a number of their friends to invest capital and form a board of directors. Paul Simon, Johnny Rivers, and record producer Terry Melcher, Doris Day's son, all matched the $10,000 Adler and Phillips each contributed. Within days, these formidable forces had secured commitments from the Mamas and Papas, Simon and Garfunkel, the Beach Boys, the Byrds, The Who, the Association, and Dionne Warwick. The festival board of directors expanded to include Rolling Stones manager Andrew Loog Oldham, Mick Jagger, Donovan, Paul McCartney, Jim McGuinn of the Byrds, Smokey Robinson, Brian Wilson of the Beach Boys, and attorney Abe Somer.

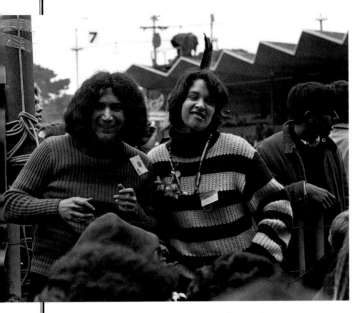

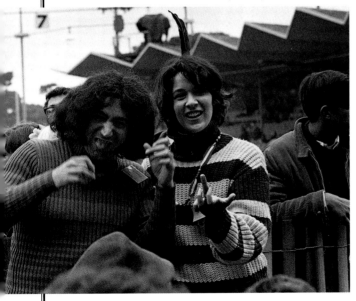

Jerry Garcia of the Grateful Dead and his friend, Mountain Girl.

The idea of filming the festival came up, and producer Bob Rafelson, who had created and later directed the Monkees for a TV series, was contacted. A deal was struck with the ABC network, which put up $250,000 for the rights. With a documentary in mind, director D. A. Pennebaker, the independent filmmaker whose brilliant film on Bob Dylan, *Don't Look Back*, was about to open, flew out from New York to discuss the project. Rafelson dropped out, leaving Pennebaker to make a couple of trips to scout the Monterey terrain and hire a film crew.

But Phillips and Adler still faced a number of problems. San Francisco held the key to the festival. The music of the Fillmore and Avalon ballrooms represented the artistic vanguard of the new rock, and the festival desperately needed the imprimatur of creativity and adventure only the San Francisco bands could supply. Of course, that also posed major difficulties, because the free-wheeling mavericks from the Haight-Ash-

bury were instinctively suspicious of Top Forty Hollywood hucksters like Adler and Phillips.

Emissaries were dispatched. First, Paul Simon went to meet with the Grateful Dead, a band whose first album had been released only recently, but who held a crucial position in the San Francisco scene. Dead managers Rock Scully and Danny Rifkin took Simon to a free concert in Golden Gate Park, where Simon, accustomed to stuffing towels under hotel room doors before lighting up, watched in shock as people smoked joints in public. He brought back the first reports.

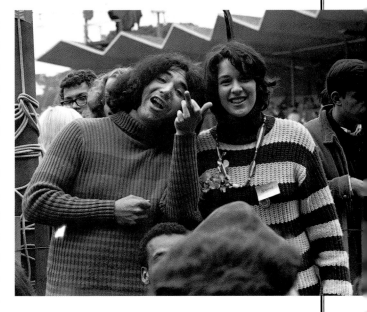

The first weekend in May, six weeks before the festival dates, Adler, Oldham, and Taylor flew to San Francisco to meet various figures and functionaries of the local music community in an effort to whip up support. Rock critic Jann Wenner at *Ramparts* magazine was non-committal, although he recommended they book the Steve Miller Blues Band.

Jazz expert Ralph J. Gleason, the first member of the daily press to cover pop music, was another matter. Starting at the *San Francisco Chronicle* in the late 1940s, when Gleason began treating the new San Francisco rock bands seriously, he brought stature and respect to the budding scene that it could not have obtained any other way. With his sharp moral sense and fearless reporting, Gleason, in his deerstalker hat, owl-eyed glasses, and handlebar mustache, considered himself the conscience of the scene. Through his

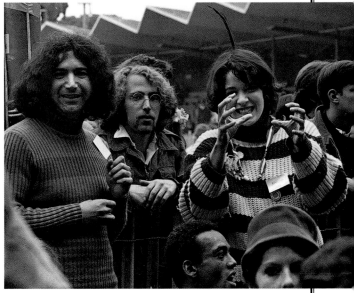

columns in the *Chronicle*, he was both a power behind the scenes and a major public influence. Adler, Oldham, and Taylor knew that without the approval of Gleason, they might as well forget about having a festival.

Like many San Franciscans, Gleason was automatically skeptical of promoters from Southern California. Adler hardly represented the kind of honest, rugged rock music Gleason liked; Johnny Rivers was decidedly not his cup of tea. Gleason would not play any part in something he saw as a Hollywood rip-off of the vital energy of the San Francisco rock scene. Adler, Oldham, and Taylor visited his Berkeley home and presented their case. He listened without judgment. "Let me know how it shapes up, and I'll let you know," he told them.

Adler also met with some of the San Francisco band managers in a room at the posh Fairmont Hotel—more his turf than theirs, even in their home town. The San Franciscans, veterans of many large outdoor rock gatherings, raised concerns about the thousands of young people who would be coming to Monterey without tickets. They talked of campgrounds, food, and medical tents. Skepticism was also voiced about performing for charities not yet named. Threats to mount an anti-festival festival were made. The vibes were anything but groovy.

These hard-nosed hippies asked difficult questions for which Adler had no good answers: Why not a free festival? What about this TV special, were there plans to release it in theaters? Why spend so much on expenses? Why does everything have to be first-class?

Danny Rifkin, co-manager of the Grateful Dead, and Emmett Grogan of the Diggers, the radical community group that handed out free food daily in the Golden Gate Park "panhandle," went to Monterey to check out the possibility of using the facilities at the nearby Army base, Fort Ord, as a campground. Rifkin met with state senator Frederick Farr at the Pebble Beach home of his partner's parents. They eventually selected the Monterey Peninsula College, almost within walking distance of the fairgrounds, and obtained permission to stage a camping site on the football field.

This talk of a rock festival alarmed the good burghers of Monterey. Mayor Minnie Coyle took issue with Adler's apparent promise, as reported in the *Chronicle* by Gleason, to give a portion of the proceeds to the Diggers to help feed the anticipated onslaught of youth headed to the Haight-Ashbury that summer. "If there are people hungry, you feed them," she said. "But don't advertise free food for everyone who wants it. That encourages youngsters to leave home."

The producers hired a Monterey-based public relations expert, Jim Chubb, a middle-aged, self-described square who was dating actress Kim Novak at the time. He arranged a meeting between festival board members and city officials. With only four weeks to go, Phillips and Adler took a Lear jet to Monterey. Also in the group were Michelle Phillips, Pariser, Taylor, and Peter Pilafian. At a luncheon meeting at the Mark Thomas Inn, John Phillips, high on LSD, proved a charming, eloquent spokesman, who was diplomatic enough to agree to anything.

First, the issue of the Diggers had to be addressed. "No money will go to a hippie under-ground organization," Phillips said reassuringly, denying published reports in both San Francisco and Los Angeles newspapers that the Diggers would be beneficiaries of the fest. Copies of the festival articles of incorporation were passed out. "The money will provide primarily scholarships to those who need them in the popular music field," said Phillips. He stressed that the event would not be simply a series of concerts, but a wide-ranging learning experience that would also feature workshops on copyright law, professional songwriting, and instrumental skills.

The board members faced a group that included not only the city's elected and appointed officials but also representatives of the local motel industry, the Monterey Peninsula Chamber of Commerce, and all the police agencies affected. In the face of outspoken skepticism by Captain Francis Simmons of the California Highway Patrol and Sheriff Jack Davenport, Phillips, looking positively Edwardian in his neatly trimmed goatee and three-piece suit, charmed the potentially hostile group by telling them whatever they wanted to hear. Mayor Coyle appointed a committee, and Phillips promised to "go along with you people on whatever you want."

With that obstacle avoided, Phillips and Adler pressed forward. Getting black artists to cooperate proved difficult. Adler worked on getting a segment of one afternoon show devoted to Motown acts like Smokey Robinson and the Miracles, the Four Tops, and others, but schedule conflicts could never be resolved. Inquiries were made about Chuck Berry, who refused to perform free. Andrew Oldham eventually reached manager Phil Walden, on tour in Europe with Otis Redding, and Walden agreed to bring his charge to the show.

With Mick Jagger and Keith Richards under drug charges in England, the Rolling Stones could never get visas to perform. Donovan couldn't appear for the same reason. To represent the British rock community, the festival would have to rely on an unknown folksinger named Beverly, The Who, an American who had formed his band in England (Jimi Hendrix), and a Briton who had formed his new band in America (Eric Burdon).

Meanwhile, Adler was about to start his new record label, Ode Records, through a distribution deal with CBS Records,. He wanted Phillips to launch the venture with a hit record. With the festival in mind, Phillips wrote a song, "San Francisco (Be Sure to Wear Some Flowers in Your Hair)." They co-produced the record for Adler's new label with vocalist Scott McKenzie, a friend of Phillips. A thoroughly Hollywood superficial take on the anticipated summer in the Haight-Ashbury, the Bel Air ballad was not calculated to win any friends among the San Francisco crowd. But it immediately took off toward the top of the charts upon release.

Plans for the festival rolled forward; all that remained was for the crowds to come.

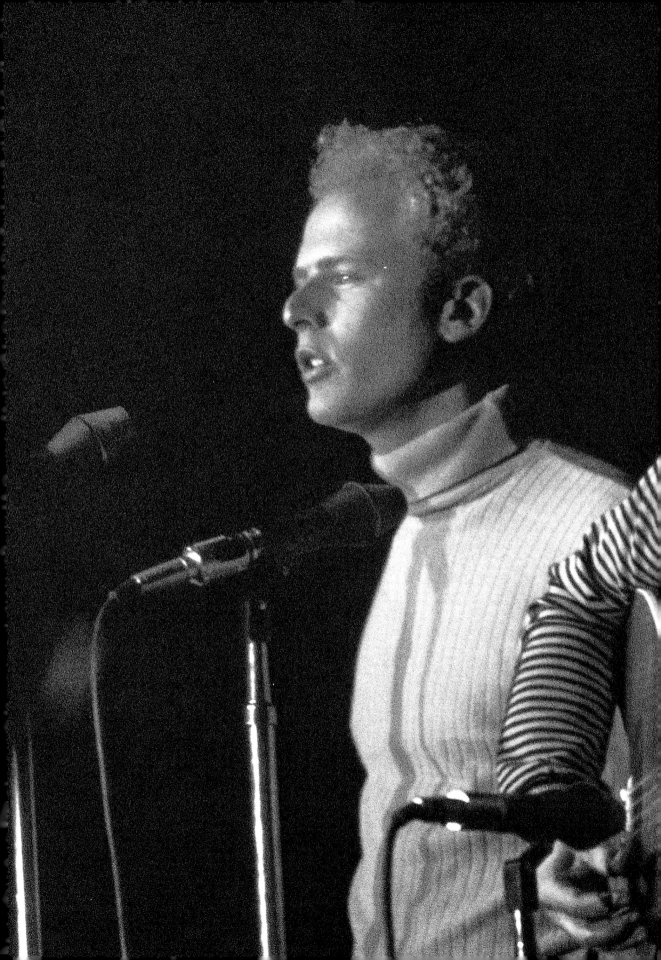

Friday Night

.

SIMON AND GARFUNKEL

ERIC BURDON
& THE ANIMALS

JOHNNY RIVERS

BEVERLY

LOU RAWLS

THE PAUPERS

THE ASSOCIATION

THEY CAME. In beat-up Volkswagens and Day-Glo buses. In parents' cars and on motorcycles. By thumb. Like a ragtag army descending on the sleepy seaside town, they swarmed over the hills carrying knapsacks and sleeping bags, unkempt, unshaven, wearing loose-fitting, colorful garments. They were mostly loaded and ready to rock, drawn to the festival, tickets or not. By mid-afternoon, all the highways leading into Monterey were jammed.

Columnist Judith Sims of <u>Teen Set</u> smiles for the camera as she exits the press section.

THE SUMMER OF LOVE AND "Sgt. Pepper" had begun. School was out, and the clarion call of California was heard around the world. The pricey, precious reserved seat tickets—from $3.00 to $5.00 for the afternoon shows, $3.50 to $6.50 for the evenings—sold out in advance (except for the Sunday afternoon show by Ravi Shankar). Fairgrounds admission was limited to ticket-holders or those willing to shell out the $1.00 fairgrounds-only admission fee. Hotel rooms were long gone. Not that any of this would keep people away.

In the first-class section of a TWA 707 waiting for takeoff on a Heathrow Airport runway in England, the party already had begun. Brian Jones pressed two white capsules into the palm of Eric Burdon, and Jimi Hendrix handed him a bottle of Jack Daniels to wash them down. In the euphoric, crazed atmosphere, Burdon felt the barriers of animosity dissolve between himself and his ex-mate from the Animals, bassist Chas Chandler, now co-

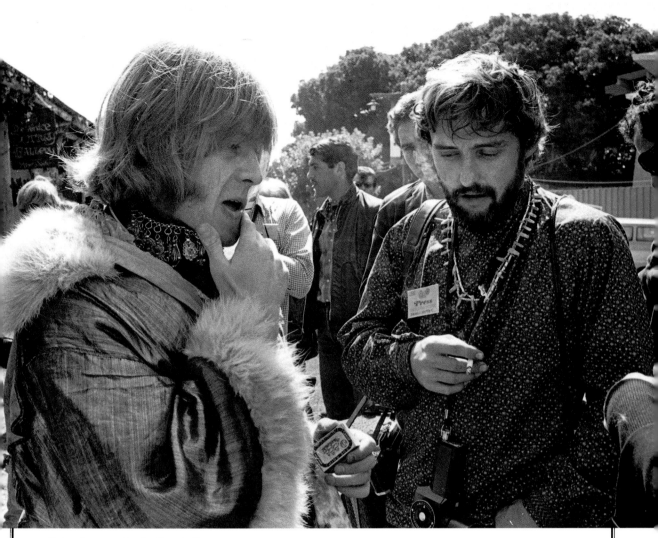

Brian Jones and actor Dennis Hopper.

manager of the Jimi Hendrix Experience. "It's gonna break him worldwide," Chandler confidently told Burdon.

At Monterey, Derek Taylor gave press credentials to anyone who asked. More than 1,100 asked. He accorded equal treatment to reporters from the *Berkeley Barb* and *Time* magazine. Actually, he probably treated the underground press better, at one point barring a *Life* magazine correspondent and crowing about the fact at a festival press conference.

Monterey Police Chief Frank Marinello deployed his entire forty-six-member force, called out more than a hundred reinforcements from surrounding towns, and alerted a National Guard encampment of 650 soldiers at nearby Fort Ord, just in case. He insisted his officers patrol the fairgrounds in full uniform, including guns and batons, but by sundown Friday, more than a few of his men were wearing flowers, handed to them by barefoot girls.

The crowd came in costumes—cowboys and Indians were popular. Those who came from Northern California knew to bring blankets for the chilly summer nights. At least one group of Southern California teens drove straight from the beach, wearing nothing but swim

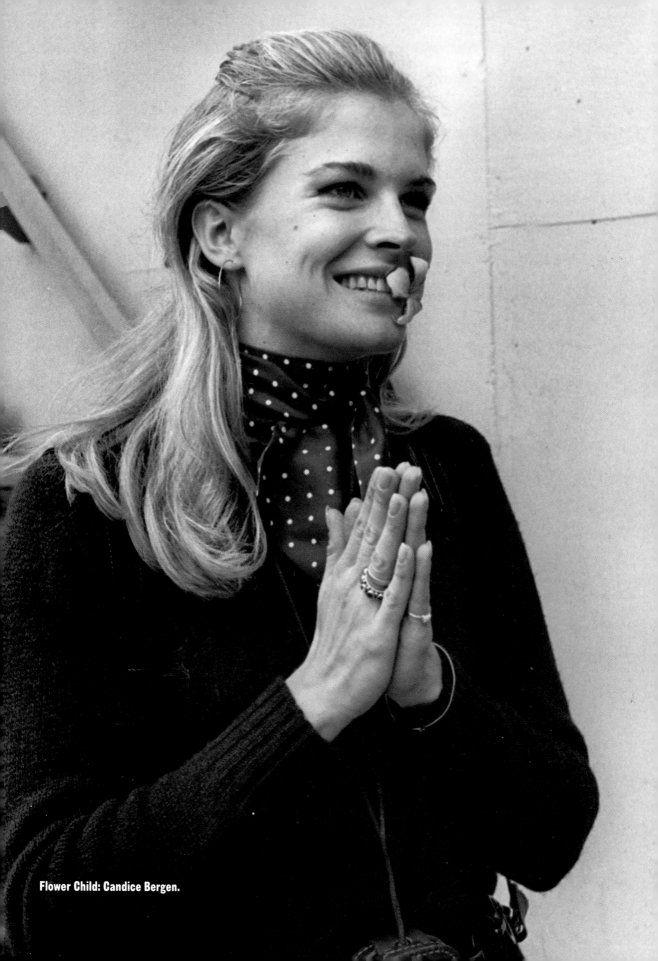

Flower Child: Candice Bergen.

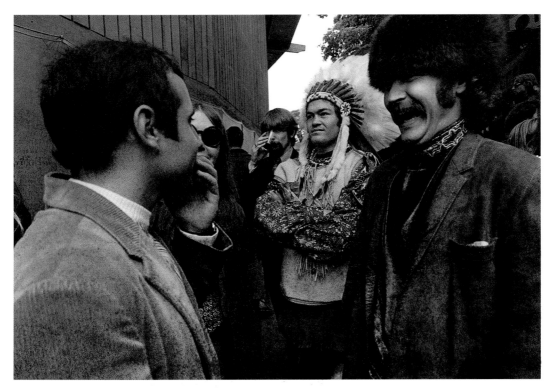

David Crosby of the Byrds shares a laugh; Mickey Dolenz in the background wearing Indian headdress.

trunks. Although supposedly barred from attending, both soldiers and Hells Angels came. And everybody entering the fairgrounds Friday was handed an orchid. The festival flew in 100,000 blossoms from Hawaii. The petals were everywhere all weekend.

Famed LSD manufacturer Augustus Stanley Owsley III arrived — with tickets arranged by Ralph Gleason — carrying pocketsful of a special batch he tabbed up specifically for the festival. He called it Monterey Purple. Although by no means the sole source of psychedelics at the festival, Owsley spread his lavender lunacy to the festival staff and musicians all during the weekend.

Stage manager Chip Monck was still building his stage Friday afternoon, finishing a scant few hours ahead of show time. His assistant stage manager, musician Al Kooper, fresh out of the Blues Project, arrived on a Lear jet from Los Angeles that also carried Alan Pariser, John Phillips, and Brian Jones. David Wheeler expected to spend the weekend grooving and watching the show. He brought his girlfriend, actress Nina Wayne, and a fancy racing car but was drafted to head festival security almost as soon as he hit the site.

D. A. Pennebaker and a six-camera crew stood ready to capture the three-day madhouse on film, and engineer Wally Heider had his remote eight-track recording equipment in a nearby van. Peter Pilafian worked to put together the arts and crafts booths. Tom

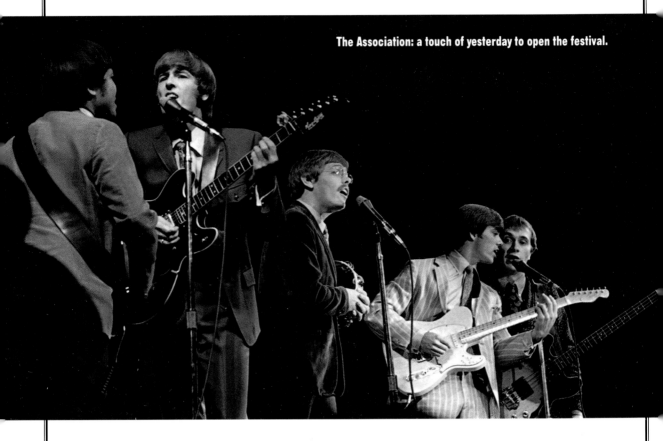

The Association: a touch of yesterday to open the festival.

Wilkes, after creating reams of graphics and an eighty-page souvenir program, turned his designer's eye to the fairgrounds itself, hanging banners and balloons.

A giant Buddha was erected on the lawn opposite the main entrance. Auxiliary buildings housed a closed-circuit television system to broadcast the arena shows. Other buildings held exhibits by various guitar and equipment manufacturers, including a new invention, the Moog synthesizer. An impromptu stage was set up for jamming, and booths carried flowers, two-day tattoos, and psychedelic arts and crafts, in addition to the usual food.

Outside the grounds, vendors hawked a newsprint program for a quarter. The elaborate souvenir book was available inside for $2.00. Conceived of as an additional way to make money, the official program—with a hand-drawn, hand-colored page contributed by no less than the Beatles themselves—sold fewer than 1,800 copies, although record company advertising at $1,500 a page nearly covered the $43,000 it had cost to produce.

Otis Redding and his manager, Phil Walden, missed their flight connection out of San Francisco and chartered a small plane to make the twenty-five-minute trip. The coastline fog above the Monterey airfield was thick. The pilot told each of the passengers to look out a different window. "When you see the runway, yell," he said.

The two repaired to the Highlands Inn overlooking the Pacific on the cliffs above Carmel, a short drive from the fairgrounds, and waited in the bar for someone to take them to the festival site. Fellow festival artist Johnny Rivers came over and introduced himself to Otis, happily taking a seat next to the soul singer. Otis was polite. "Are you our driver?" he asked.

By showtime, the police estimated as many as 30,000 people had descended on the festival. Only 7,000 held tickets to the arena, where they were greeted by ushers wearing signs reading "Seat Power—We Love You." Many festival staffers sported badges with a motto lifted from the new Beatles album: "A Splendid Time Is Guaranteed for All."

Special dress circle tickets had been sold to the elite of the record business for as much as $150 a ticket. Among those attending were Columbia Records chairman Goddard Lieberson, Columbia Records president Clive Davis, Warner Brothers president Mo Ostin, Jerry Moss of A&M Records, and Jerry Wexler of Atlantic Records. The Hollywood contingent included actress Candice Bergen, actor Dennis Hopper, and TV's Doug McClure of "The Virginian."

Mickey Dolenz of the Monkees, whose great-grandfather was a Chickasaw, showed up in full Indian headdress. His colleague Peter Tork posed for as many pictures backstage as he could. Even though not invited to perform, these two credibility-starved members of the immensely popular but artificial group were backstage throughout the weekend. Phil Volk, recently departed from Paul Revere and the Raiders, was another bubblegum musician hanging out, hoping some of the Monterey mystique might rub off.

Wheeler and Pariser hugged

The Paupers: underground rock from Canada, courtesy of manager Albert Grossman.

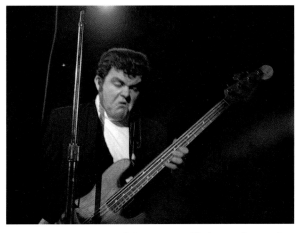

Bassist Dennis Gerrard of the Paupers: his bass solo was the festival's first musical highlight.

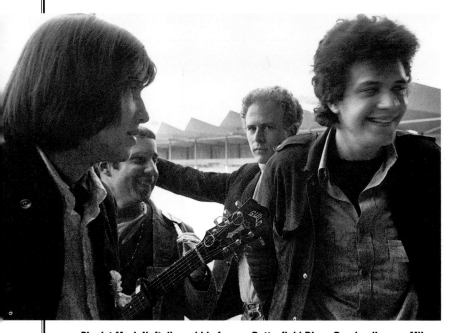

Pianist Mark Naftalin and his former Butterfield Blues Band colleague Mike Bloomfield onstage with Paul Simon and Art Garfunkel during sound check.

each other backstage as the curtain parted and the Association opened the festival with "Enter the Young," an insipid folk-rock number wrapped in barbershop harmonies. The six-man group was in the highest reaches of the best-seller charts at the time with "Windy," after lodging two Top Ten records the previous year, "Cherish" and "Along Comes Mary," a song whose alleged allusion to marijuana (the "Mary" of the title) was the group's only tenuous connection to the hip underground.

Otherwise the Association was the latest in a long line of clean-cut, collegiate singing groups in suits and ties who were descended from the Kingston Trio. With Larry Ramos replacing original member Gary Alexander on guitar and vocals, the new lineup brought highly unhip cornball antics and lounge act novelties to the Monterey stage.

In order to secure the services of the Paul Butterfield Blues Band and the new Mike Bloomfield group for the Saturday afternoon show, festival bookers also had to find room for the Paupers, another act managed by hard-fisted Albert Grossman, who carried serious clout through clients such as Bob Dylan and Peter, Paul and Mary. A Canadian quintet with three drum sets and a debut album due to be released later that summer, the band was positioned by Grossman to make the next underground rock splash. Bassist Dennis Gerrard brought the set to a close with an impromptu stuttering, rumbling bass solo that exploded into an exhibition of interference and feedback and brought the crowd to their feet cheering, the first musical highlight of the festival.

When Peter Tork of the Monkees waltzed onstage to introduce the next act, he received polite applause and only a few hysterical shrieks from teenyboppers. He was visiting unfamiliar territory. Tork brought on Lou Rawls, describing him as having "a voice we all wish we had."

Rawls was supposed to bring a touch of soul to the fest, and the onetime gospel singer

and member of the Pilgrim Travelers had once sung convincingly alongside Sam Cooke on Cooke's "Bring It on Home." But Rawls had spent too much of his recent past entertaining in hotels and supper clubs, and his turtleneck-clad act was a long way from grits and cornpone.

Backed by the house band of Hollywood session players, augmented with additional horns and conducted by musical director H. B. Barnum, Rawls put on a show better suited to Vegas than Monterey, blending show tunes and standards

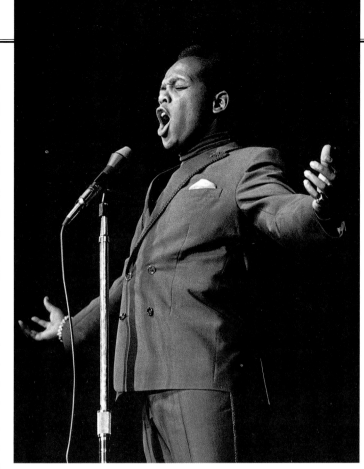

Lou Rawls: soul would have to wait.

like "On a Clear Day You Can See Forever" and "Autumn Leaves." He even trotted out that hoary showroom cliché, the medley. He introduced the bluesy "Tobacco Road" with an extended, sassy jive monologue that effectively undermined the gut emotion of the song. Soul would have to wait at Monterey until the following night.

Peter Tork of the Monkees introduced Lou Rawls: not many shrieks.

Next was a British folksinger who called herself Beverly. Her real name was Maureen McGeehie, and she had been picked by Paul Simon as his talent discovery to play the festival. They knew each other from Simon's days in London two years earlier, before "The Sounds of Silence." She and Simon's partner, Art Garfunkel, had wandered the festival grounds together that afternoon. After Monterey, she would record with slight success, singing with her husband, British folksinger John Martyn, under the name Beverly Martyn. Her obscurity

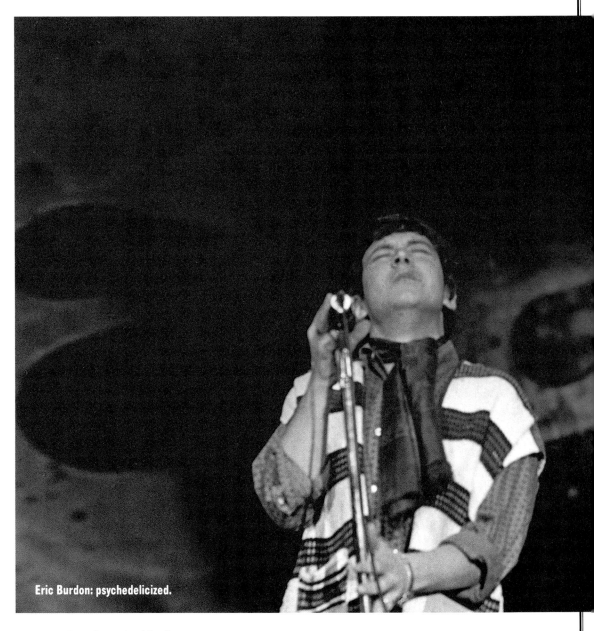

Eric Burdon: psychedelicized.

remained undisturbed by her appearance at Monterey.

It was probably inevitable that Johnny Rivers would perform at Monterey, given his connection to Lou Adler and his initial investment in the fest, although his sleek, commercial music was almost entirely antithetical to the spirit Monterey would celebrate. But he did have hits. "Poor Side of Town" had been number one the previous year, and his whiteface version of Smokey Robinson's "The Tracks of My Tears" was currently ascending the charts.

Adler had launched Rivers with a "live" recording of his act at the Whiskey-a-Go-Go,

where Rivers served up reheated rock and roll dance numbers. His first hit was a version of Chuck Berry's "Memphis," from the album that had cashed in on the go-go craze of 1964. Adler managed to keep him on the charts with a string of uninspired remakes such as "Maybelline," "Mountain of Love," "Seventh Son," and "Where Have All the Flowers Gone?" culminating in the previous year's smashes: the scorching TV theme "Secret Agent Man" and "Poor Side of Town," his first number one record. Another Motown cover, "Baby I Need Your Loving," had preceded "The Tracks of My Tears" into the Top Ten earlier in the year. Yes, he did have hits.

But little else. The musicians in the house band were the same hired guns who backed Rivers on his records—drummer Hal Blaine, bassist Joe Osborn, guitarist Mike Deasy, with songwriter Jimmy Webb sitting in on piano—but with his utter lack of charisma and the absence of Adler's atmospheric production, Rivers couldn't make his songs come to life on the festival stage. Monterey was not about having hits.

Eric Burdon was a different matter. He, too, had hits, but he wouldn't sing them at Monterey. From Newcastle, England, Burdon had burst on the scene with the 1964 worldwide smash "House of the Rising Sun." As leader of the Animals, he had scored a steady succession of hits and had retained the group's name after the original quartet disbanded the year before.

Introduced to LSD in England, Burdon had been truly psychedelicized earlier in the year on a visit to San Francisco, where he met the Grateful Dead and Big Brother and the Holding Company. He took Owsley acid and checked out the Fillmore scene. Burdon then moved to Los Angeles to form a new band. One of the first gigs for Eric Burdon and the New Animals was the Monterey Pop Festival.

With the glorious liquid projections of Jerry Abrams' Head Lights, direct from the San Francisco ballrooms, slithering and pulsing behind him on the stage backdrop, Burdon opened with a new song, "San Franciscan Nights," a song he would not record until later that summer. He belted "Gin House Blues," introducing the song slyly: "This is dedicated to the god Bacchus . . . a song of the past." Burdon and the band roared through "Hey Gip," extrapolating the Donovan number against a locomotive Bo Diddley undercurrent. Guitarist John

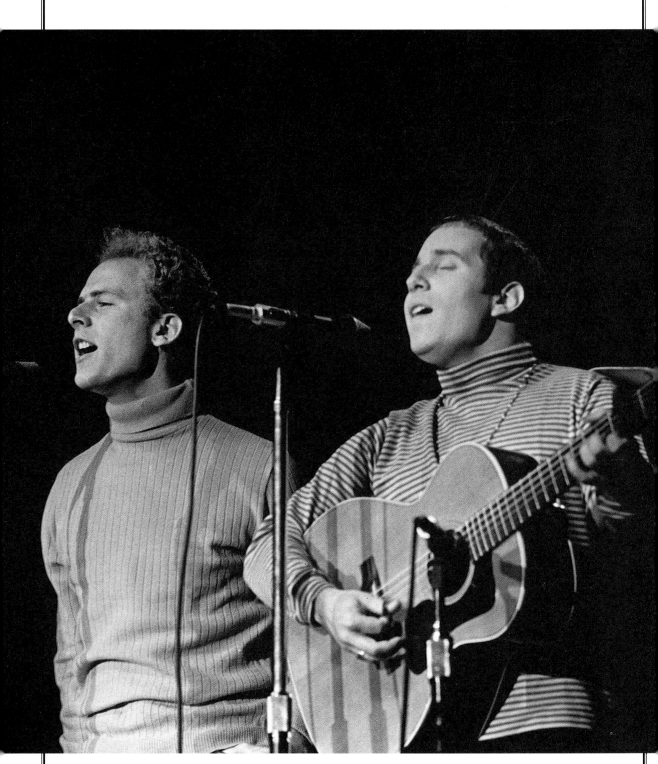

Still pure: Art Garfunkel and Paul Simon.

Wieder picked up the violin for an extended, acidified "Paint It Black." Burdon did nothing short of reinvent himself in front of the Monterey audience.

Paul Simon and Art Garfunkel, key players in the backstage drama to make Monterey happen, made perfect sense as one of the weekend's headline attractions. The two choirboys represented the height of the neo-pop/folk movement. Simon, still renting a rundown New York apartment and slightly awed by the luxury surrounding John Phillips, could kid the Beverly Hills folk-rocker, "We're folk, we're still pure."

And Simon's exquisitely crafted compositions did manage the delicate balance of poetic lyrics and folk-inspired melodies. Coupled with the angelic voice of his longtime musical associate, Simon had created late-night romantics for the college crowd with their album "Parsley, Sage, Rosemary and Thyme," striking a deeply resonant nerve. Only two years earlier, he had been scraping for pennies in England, and he still sported a slight pseudo-English accent.

"We'd like to introduce to you at this time," Phillips told the crowd, "two very good friends of mine and two people who, in the music business, are respected by everyone." Accompanied only by Simon's acoustic guitar, the pair brought the first concert of the festival to a close with a brief performance that began with the hit "Homeward Bound" and then promptly veered into the darkish/frolic of a new song, "At the Zoo."

Telling the crowd that he had spent most of 1965 in England, returning to the U.S. only after "The Sounds of Silence" took off, Simon explained the genesis of the next song: "I had to make this adjustment from being relatively unknown in England to a semi-famous type of scene here, and I didn't really swing with it. It was a very difficult scene to make. Very unhappy. All the songs I was writing were very down, depressed type of songs until about June last year. I started to swing out of it, got in sort of a good mood, and I remember comin' home one morning about six across the Fifty-ninth Street bridge in New York. It was such a groovy day, really, a good one. . . ."

"Feelin' Groovy" gave way to the nearly emetic "Emily, Whenever I May Find Her" ("This is my favorite song," said Garfunkel). They closed with "The Sounds of Silence" and returned for an encore with a sixteenth-century Benedictus and a new song by Simon called "Punky's Dilemma" with the memorable opening line, "I wish I were a Kellogg's Cornflake."

Like a bookmark, the smart-alecky song served to mark the place where the festival would pick up the next day.

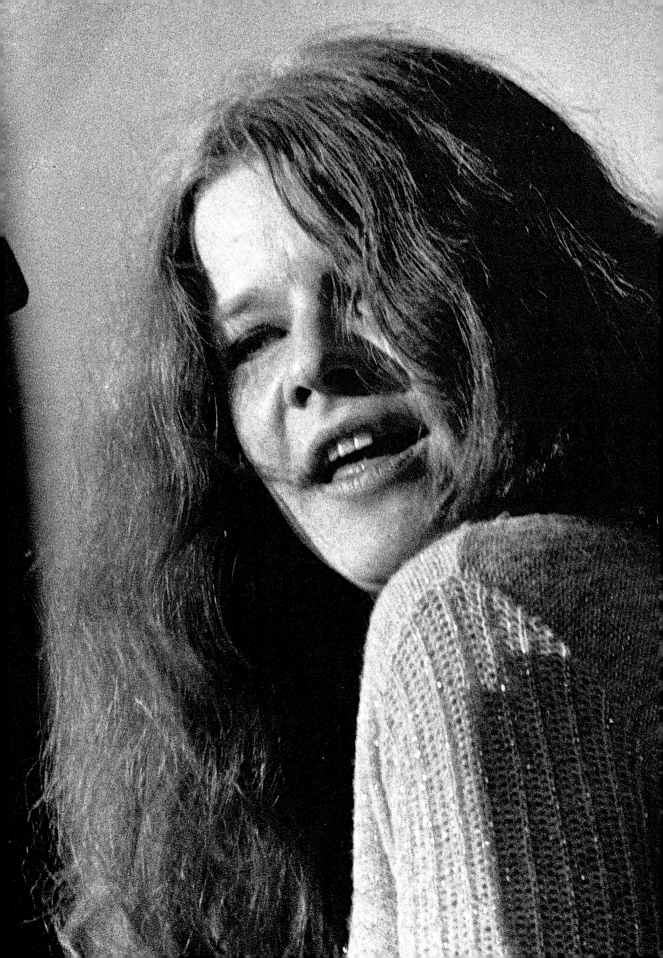

Saturday Afternoon

· · · · · · · · · · · · · · · · · ·

ELECTRIC FLAG

STEVE MILLER
BLUES BAND

QUICKSILVER
MESSENGER SERVICE

PAUL BUTTERFIELD
BLUES BAND

AL KOOPER

COUNTRY JOE &
THE FISH

BIG BROTHER &
THE HOLDING COMPANY

CANNED HEAT

THE FOLLOWING AFTERNOON, the festival started in earnest. With the first performance by Electric Flag, the new group led by guitarist Mike Bloomfield, primed as the main event, the afternoon card was filled with white-boy blues bands and other Young Turk contenders from San Francisco, the rough diamonds of a provincial scene not yet heard far beyond the confines of the San Francisco ballrooms. After a somewhat stodgy, slightly commercial Friday evening of few surprises, the fest was now set to start exploring the world of new music, the original mandate of the producers.

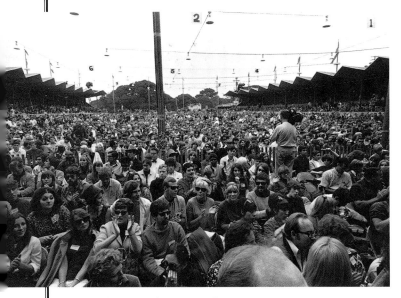

The Saturday afternoon audience

THE SEASONAL MONTEREY FOG left a dewy mist on the lawns and arena seats. The musty odor of marijuana was everywhere by the time Canned Heat opened the festivities. Without anything but a growing local reputation, this blues-based boogie band stepped onto the Pop Festival stage almost directly from a small Hollywood niterie, the Kaleidoscope, where Canned Heat had been serving as unofficial house band. A record deal had been signed with Liberty Records. A single of the Muddy Waters blues "Rollin' and Tumblin'" idiomatically correct, group original, "Bullfrog Blues," was slated for imminent release. But essentially, the band was entirely unknown outside hip circles in L.A.

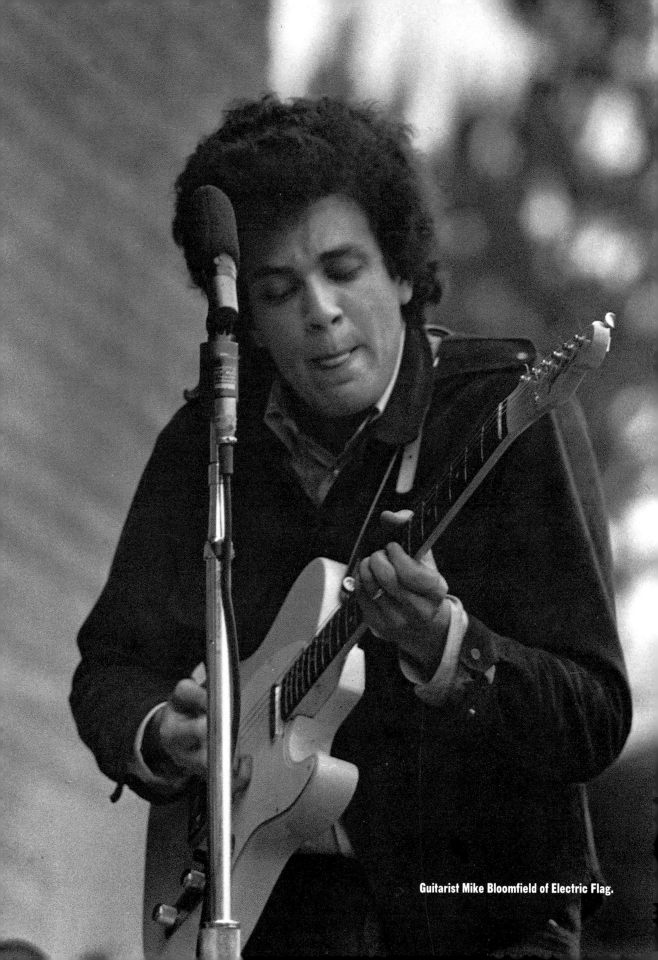

Guitarist Mike Bloomfield of Electric Flag.

Festival director Lou Adler (left) backstage with Chet Helms (center) of the Avalon Ballroom.

Corpulent vocalist Bob (Bear) Hite, who weighed in at more than 300 pounds, had been working in a record store two years earlier when he met guitarist Alan Wilson, a partly blind music major and fellow blues fanatic from Boston University. With drummer Frank Cook, they formed a jug band, their repertoire drawn from Hite's huge collection of rare blues 78s. Their enthusiasm far outweighed their experience when the comrades-in-blues played their professional debut at the Ash Grove on Melrose Avenue, a long-standing center of the L.A. folk scene.

The group soon dissolved but re-formed after a chance one-nighter led the band to regular work at the Kaleidoscope early in 1967. They were augmented by a pair of battle-tested musicians who brought a more sturdy musical backbone to the party: guitarist Henry Vestine, a former member of the Mothers of Invention who was highly regarded for his skills, and

bassist Larry Taylor, another music business veteran who had started out on the road at age fourteen with Jerry Lee Lewis.

With "Blind Owl" Wilson playing bottleneck guitar, reprising an old country blues technique largely new to rock fans, and Hite putting his husky vocals to the jaunty rhythmic drive of the band, Canned Heat experienced no problem starting the first afternoon on a warm, upbeat note. Cutting a distinctly plebeian image in their "uniform" of work shirts and jeans, Canned Heat worked hard enough to give drummer Cook a blister. It was a rough but avidly received performance. It might have been remembered even better had it not been for what happened next.

Brewing backstage was the first open confrontation between the San Francisco and Hollywood contingents. Manager Julius Karpen of Big Brother and the Holding Company made it clear his band would not take the stage until the cameras filming for the TV special were pointed toward the ground. He had no intention of allowing the band to participate in a project over which they held no artistic control. He instinctively distrusted Adler as the kind of snake-oil salesman antithetical to every precept Karpen held dear. Few people outside San Francisco had ever seen the band. Big Brother had been booked on the basis of a reputation reported secondhand to the producers, and the loss to the filming was, at first, not presumed to be critical.

The band came to Monterey knowing the festival could be the big opportunity to break loose. The musicians had dutifully assembled every day for weeks before the date and scrupulously rehearsed the same songs over and over in preparation for the half hour in the limelight. They arrived in Monterey knowing nothing about any filming or the TV special.

Chet Helms of the Avalon Ballroom took a proprietary interest in the band. Not only did he serve as their original manager—the Big Brother of the band's name—but he was also the person who brought vocalist Janis Joplin into the fold.

"Three or four years ago," he said to the crowd, "on one of my perennial hitchhikes across the country, I ran into a chick from Texas by the name of

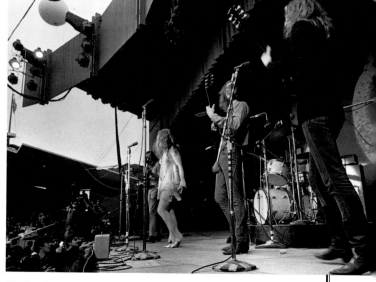

Big Brother and the Holding Company perform on Saturday afternoon.

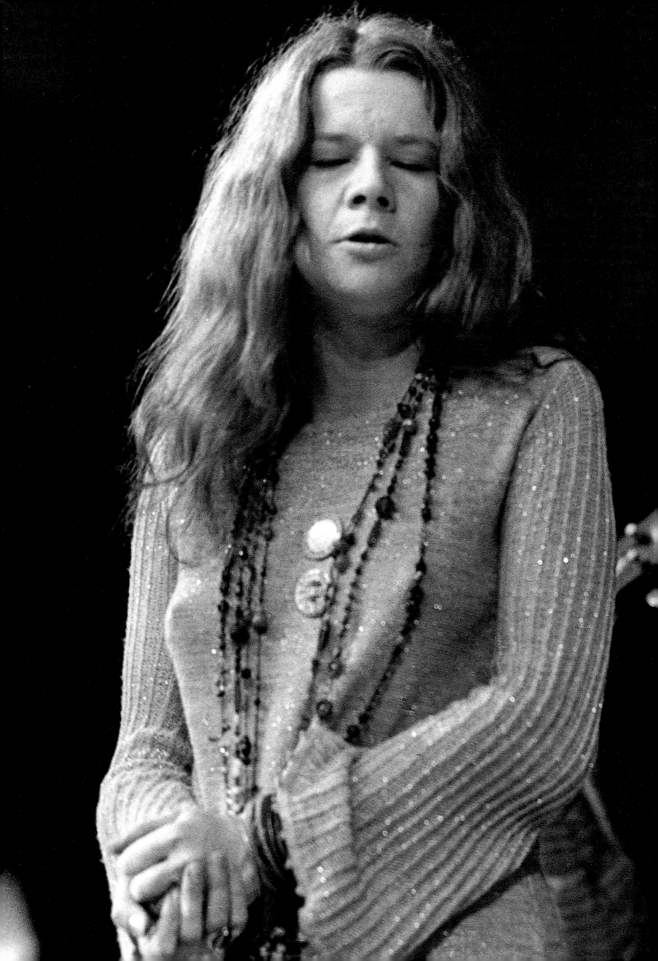

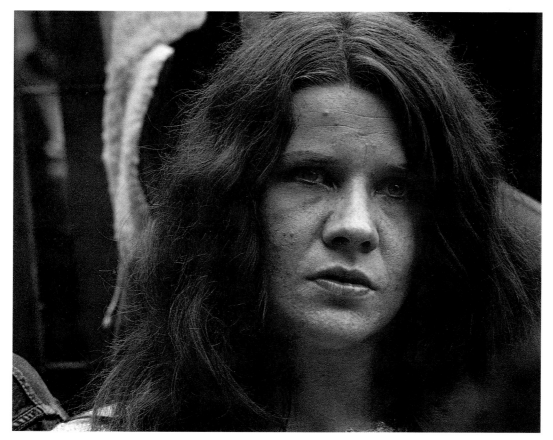

Janis Joplin of Big Brother and the Holding Company.

Janis Joplin. I heard her sing, and Janis and I hitchhiked to the West Coast in fifty hours, probably the fastest trip across the country we ever made. A lot of things have gone down since, but it gives me a lot of pride today to present the finished product . . . Big Brother and the Holding Company."

Drummer David Getz struck the downbeat, and Janis Joplin launched "Down on Me," driving a voice like rusty nails into the song. Before the crowd could catch a breath, she picked up a ratchet-sounding percussion piece, scraping a stick against it, as guitarist James Gurley let his animal loose — wheezing, screeching, ballooning into feedback. Sam Andrews took the ostensible lead vocal on "The Combination of the Two," but it was Joplin who took the song away with her "whoooo-whoa-whoa-whoa" into a bridge where she chastened the crowd, "We're gonna knock ya, rock ya, sock it to ya."

It was as if the earth had opened up. Her voice commanded the ear. She vibrated from deep within. Once she opened her mouth and sang, this otherwise unprepossessing person seemed to grow taller before the audience's eyes. Against a scratching, atonal guitar riff, she

shrieked wordlessly, building to a quick cataclysm, where she hollered one word, "Harry," and petered out. A blues-based rock song, "Road Block," followed. If she had not yet splintered the audience's brains, she was about to.

Willie Mae (Big Mama) Thornton used to sing "Ball and Chain" at blues festivals and college concerts, when interest in her career had been revived during the early '60s. But Janis Joplin found something in that song she could make all her own. "We've got one more song," she mumbled in a surprising little-girl voice. "It's called 'Ball and Chain.'"

Stomping her heel hard enough to break through the stage, she sang as if she wanted to swallow the song whole. She caressed the verse and exploded on the choruses into paroxysms of raw emotion, her voice struggling for feelings that could not be articulated. The audience was spellbound, startled at the crude power unleashed, and they rocked the arena with cheers and applause.

Country Joe in warpaint.

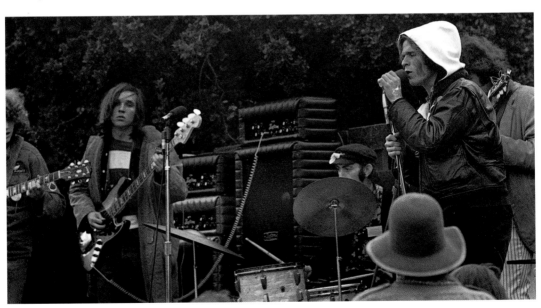

Country Joe and the Fish jamming on the festival grounds (left to right): Barry Melton, Bruce Barthol, Chicken Hirsh, Country Joe McDonald.

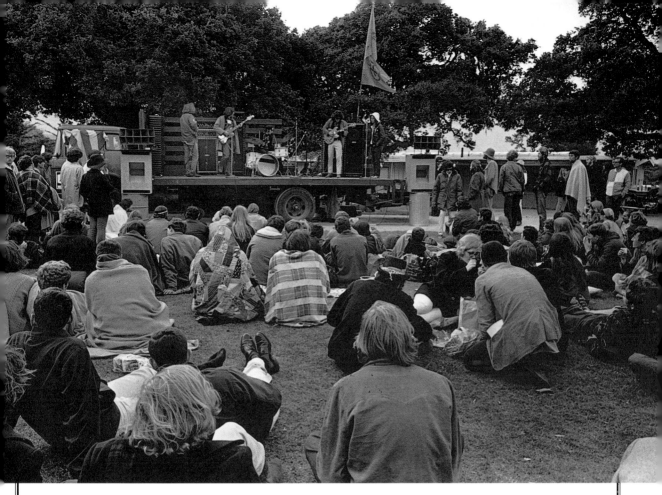

She was the first real hit of the festival, a taste of what everybody had come to see. Janis Joplin had raised the stakes of the game, but wasn't quite sure herself what exactly had happened. "Do you think I'll make it?" she asked Mark Naftalin of the Paul Butterfield Blues Band backstage.

Slowly, it began to dawn on her that she had given what could possibly be the performance of a lifetime, and the movie cameras had not recorded it. She went to John Phillips, tears streaming. Lou Adler told her he would find another slot for her to repeat the performance, if she would sign the necessary releases. The band was not sure, but she sought the advice of Albert Grossman, Dylan's powerful manager, who said he thought it would do her career good. Ralph Gleason took Julius Karpen aside and told him sharply he thought Karpen was making a crucial mistake.

Following the incendiary Big Brother performance might have been difficult, if that sort of thing mattered to Country Joe McDonald. Zonked as he was on a dose of Owsley's latest creation called STP, he hardly noticed. Blissfully out of it, his face covered in warpaint, McDonald led his colleagues in Country Joe and the Fish through a typical performance that combined far-out acid-rock improvisations like "Section 43" with the jug band theatrics of McDonald's LSD commercial, guitarist Barry Melton urging, "Please Don't Drop That

H-Bomb on Me" or the anti-war irreverence of "Feel Like I'm Fixin' to Die Rag."

Once the official performance on the arena stage was completed, the band wandered across the festival grounds to where a lesser-known San Francisco band called Mount Rushmore was playing on the auxilliary stage. Before long, most of the band had assembled on the smaller stage on the fairgrounds, jamming away.

Over in the Guild guitar booth in the exhibition hall, Bob Weir of the Grateful Dead found himself plugged into the same amplifier and swapping lines with a woolly-haired black guitarist he'd never met named Jimi Hendrix. With them was a short acoustic guitarist, Paul Simon.

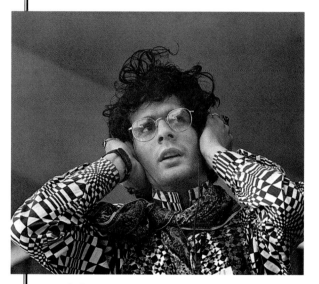

Assistant stage manager Al Kooper.

Assistant stage manager Al Kooper threw together a quick set on the arena stage. He had left the Blues Project only a few weeks earlier, telling his bandmates an accidental acid dose had caused him to have a nervous breakdown. The keyboardist and vocalist had moved to California and hooked up with the festival staff after his former band had already been booked. They suspected Kooper would try to upstage them by playing some of the same material they planned to use.

While anticipation focused on the new Mike Bloomfield band scheduled to appear later in the afternoon, the Paul Butterfield Blues Band remained an attraction, even without the stellar services of Bloomfield, the band's erstwhile guitarist. Since Bloomfield had left the fold three months earlier, Elvin Bishop, the band's other guitarist, had grown so much in his confidence and abilities that he took the foreground by himself. Butterfield had also added a two-piece horn section. And Butterfield himself was an extraordinarily soulful vocalist and a near virtuoso on harmonica.

But the truth was, the incandescence of the early Butterfield band had depended on an axis of personalities, one end of which had turned on Bloomfield. So, however much exuberance the musicians put into "Born in Chicago" or however despondent Butterfield's vocal was to "Driftin' Blues," the band appeared at Monterey with its luster dimmed.

Along with the Airplane, the Dead, and Big Brother, Quicksilver Messenger Service ranked as one of San Francisco's original headline acts and was one of the first San Francisco bands to join the Monterey lineup. The band did not have a record deal, although Benny Shapiro had used Quicksilver for a pair of songs on a sound-track album the previous year.

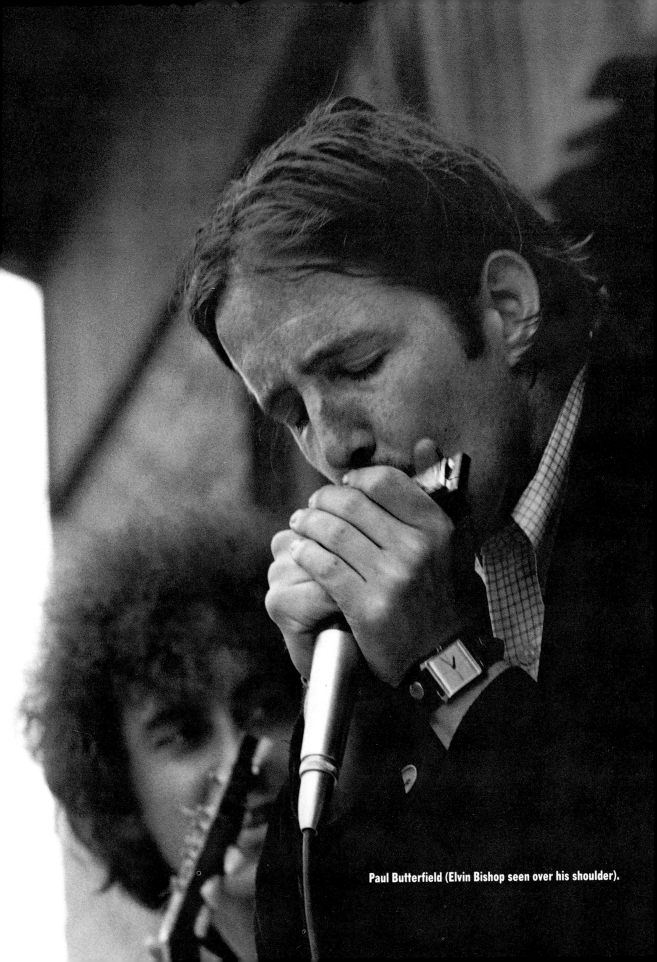

Paul Butterfield (Elvin Bishop seen over his shoulder).

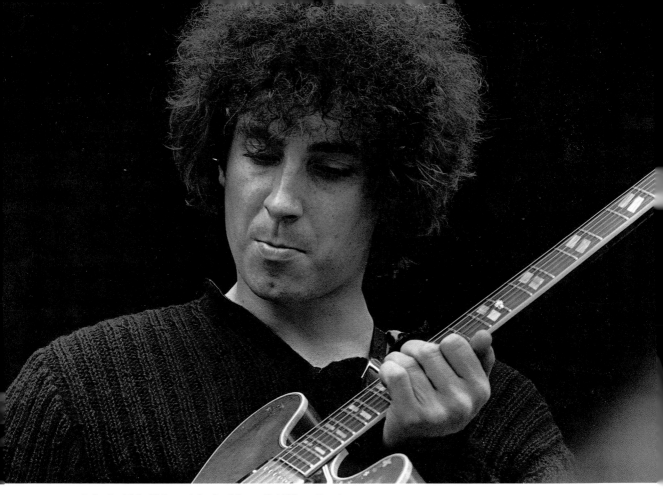

Guitarist Elvin Bishop of the Paul Butterfield Blues Band.

But the five-man band featured a three-guitar front line and could produce a sometimes-ingenious personal blend of electric rock and folk styles. The band revolved around guitarists John Cipollina, Gary Duncan, and Jimmy Murray, who also served as lead vocalist in tandem with bassist David Freiberg.

The Quicksilver had lived on a ranch in the remote reaches of Marin County in a scene laced with LSD and young ladies. Cipollina even kept a wolf as a pet. These inveterate hippies were managed by Ron Polte, part visionary, part street hustler, who never budged from his initial refusal to allow his band to participate in Adler and Phillips' TV special.

With the abbreviated set not leaving the band time for its trademark extended jams, Quicksilver never worked up a full head of steam, so the band's brand of bluesy head music failed to make the impression forged by other bands featuring more vivid personalities.

Steve Miller had lived in his Volkswagen bus the first three months he spent in San Francisco. The previous December, his band had earned the princely sum of $500 playing at the Avalon one weekend. Monterey was an opportunity, and he had decided to make it a big production.

Film crew captures Paul Butterfield performance on Saturday afternoon.

Miller hired Berkeley sound engineer John Meyer to build a special system for him, including four Klipschorn speakers in custom cabinets and a separate fuzztone box. He put together a tape recorder operated by a foot switch with fast-forward, stop, and play positions, and he made a tape featuring various sound effects. The complex design was not finished until the day of the performance. They showed up, set it up, and Miller used it. He grew very angry.

Instead of a booming, ringing tone to his guitar, what he heard sounded to him like something with all the fidelity of a loud telephone. He had invested a substantial sum in the project, and money was scarce for a struggling musician like Miller.

He used the tape recorder to add a dragster to the beginning of "Living in the U.S.A." and some backward recordings to a free-form electronic piece, searching for the cues with his foot on the switch. But the band excelled at boogie-blues numbers like "Mercury Blues," a song the group had recorded for Shapiro's *Revolution* soundtrack. Despite Miller's disappointment, the Steve Miller Blues Band emerged from Monterey as one of the day's best-received acts, although manager Harvey Kornspan went along with the other San

Francisco band managers in not allowing the festival producers to film the set.

On the fairgrounds, the event was taking on all the appearances of a genuine love match.

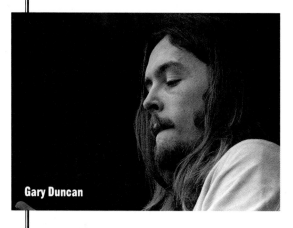

Gary Duncan

The police were covered in flowers and gifts from the concert-goers. The flagrant marijuana smoking was ignored by authorities. A small tent city had grown up overnight on the fairgrounds' lawns. There had not been a whiff of trouble: no drunken brawls, no ugly incidents, none of the public unpleasantness that normally accompanies public gatherings of this size — the annual jazz festival, for instance. One policeman noticed the crowd even pushed and shoved each other less than at the jazz fest.

Jim Murray

Monterey Mayor Minnie Coyle got in the act. "When I was first approached, I was reluctant to let the festival happen," admitted the amiable grandmother and second-term mayor at a Saturday press conference. "But I am very agreeably surprised that this is being run so well and that everyone is behaving so well. The only difficulties are relatively minor. I have been getting calls from residents in Seaside and Pacific Grove about the loudness of the music. It carries very well on the low air-belt we have." The last comment brought cheers from the hardly hardened press covering the festival. Later that night, press agent Derek Taylor disappeared, hanging a sign on his hotel room door that read, "I cannot relate to your problem."

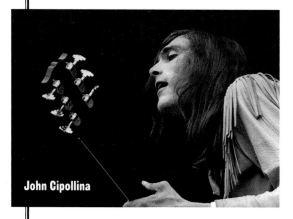

John Cipollina

Advertised in the advance publicity as the Mike Bloomfield Thing, the afternoon's climactic act was so fresh that it had only just recently coined the name Electric Flag. Manager Albert Grossman had first suggested they call the group The Band. But it wasn't until Quicksilver manager Ron Polte returned from a Northern California concert at an American Legion hall and reported seeing an electric-lighted American flag that the band was named.

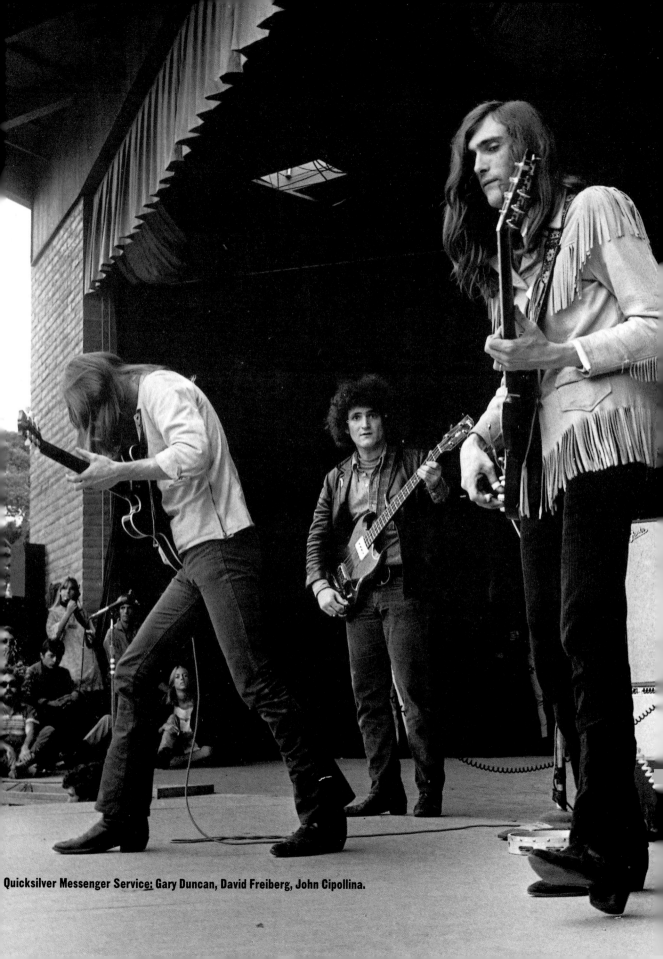

Quicksilver Messenger Service: Gary Duncan, David Freiberg, John Cipollina.

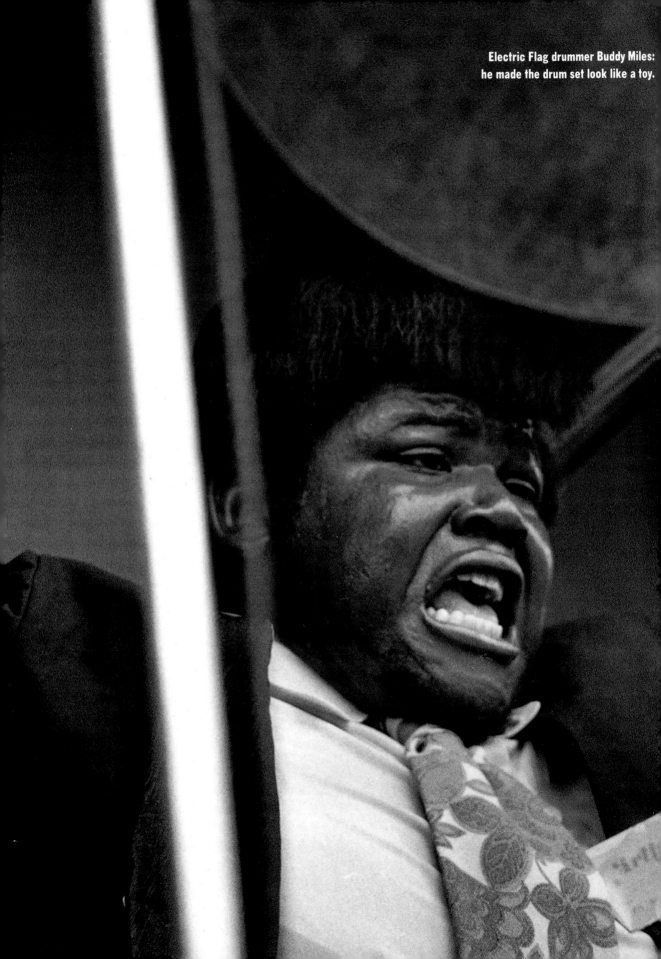

Electric Flag drummer Buddy Miles:
he made the drum set look like a toy.

Nick Gravenites

Mike Bloomfield

Several months earlier, guitarist Mike Bloomfield had discussed his concept for his new group while visiting Canned Heat drummer Frank Cook in Hollywood. He envisioned a group with a horn section based on the Stax/Volt blues sound of Albert King on his "Born Under a Bad Sign" album. Butterfield's manager Grossman had offered to help Bloomfield put it together. Bloomfield had contacted his old friend and musical associate, keyboardist Barry Goldberg, nephew of U.N. ambassador Arthur Goldberg. Mitch Ryder was the first person they asked to join as vocalist — Bloomfield had played guitar on Ryder's big hit, "Devil with a Blue Dress/Good Golly Miss Molly" — but the Detroit rocker passed on the offer.

Another old colleague, Nick Gravenites, who wrote "Born in Chicago," was living in Marin with Polte. Gravenites rented a house for Bloomfield in Mill Valley, and Bloomfield began dispatching musicians to the Bay Area.

Bloomfield had met drummer Buddy Miles when the huge black man was playing with soul star Wilson Pickett and relegated to traveling in the trailer with the equipment. When Miles arrived in San Francisco by plane, Gravenites duly met him at the airport, stopping on the way back to Mill Valley at the Quicksilver Messenger Service house for a large turkey dinner and a marijuana smoke-off. On the ride home, Miles made Gravenites pull over while he got out and vomited the remains of the meal, his hand poised on the hood of the truck, shaking the entire vehicle with each heave.

The band had moved temporarily to Los Angeles, ensconced themselves in a pink mansion in the Hollywood hills, and composed and recorded a soundtrack to a Roger Corman quickie exploitation movie called *The Trip*, starring Peter Fonda, Susan Strasberg, Bruce

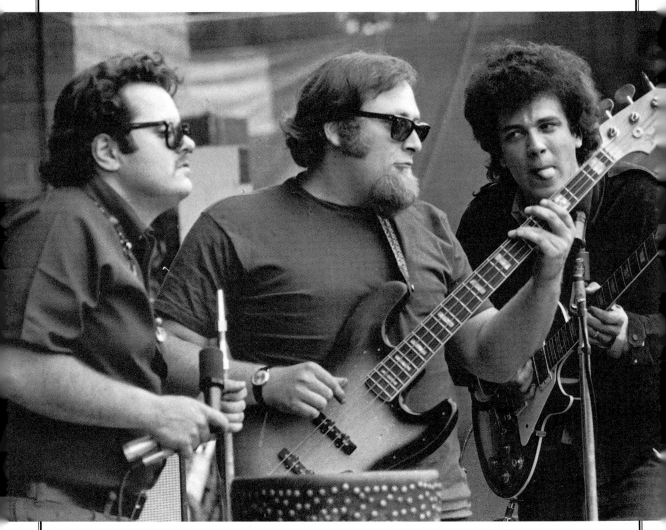

Electric Flag (left to right): Vocalist Nick Gravenites, bassist Harvey Brooks, guitarist Mike Bloomfield

Dern, and Dennis Hopper and written by Jack Nicholson. Monterey would be the band's first public appearance.

Phillips handled the introduction, calling Bloomfield "one of the two or three best guitarists in the world." He certainly took the stage with an enormous reputation, based not only on his sterling work on the first two, highly acclaimed Butterfield albums but his limelight sideman work on Dylan records such as "Like a Rolling Stone." Bloomfield was jacked up.

"We're really nervous," he gushed, "but love you all, man, 'cause this is very groovy. Monterey is very groovy. This is something, man. This is our generation, all you people. We're all together. Dig yourselves. It's really groovy."

Gravenites took the vocals to the more down-the-alley blues songs, and Miles handled

the gospel-oriented soul. Wearing a suit and tie he was leaking out of like an overstuffed sausage, Miles looked like the Baby Huey of rock, his giant pompadour left over from his tour of duty on the chitlin circuit. The behemoth loomed over his drum set, making the regulation kit look like a toy.

The audience went crazy for Miles, their first taste of genuine black soul after more than four hours of white blues. Overwhelmed by the emotion of the moment, his first performance in front of an all-white audience, Miles hobbled offstage sweating and crying, reluctant to return for an encore until someone literally pushed him back onstage.

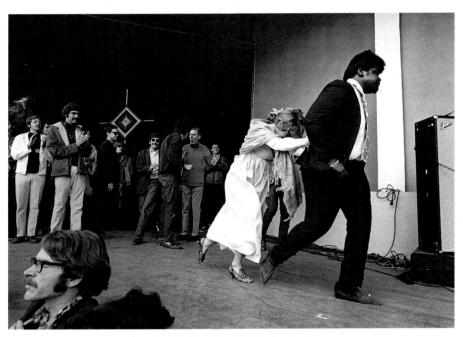

**Electric Flag: Buddy Miles had to be
pushed onstage for an encore.**

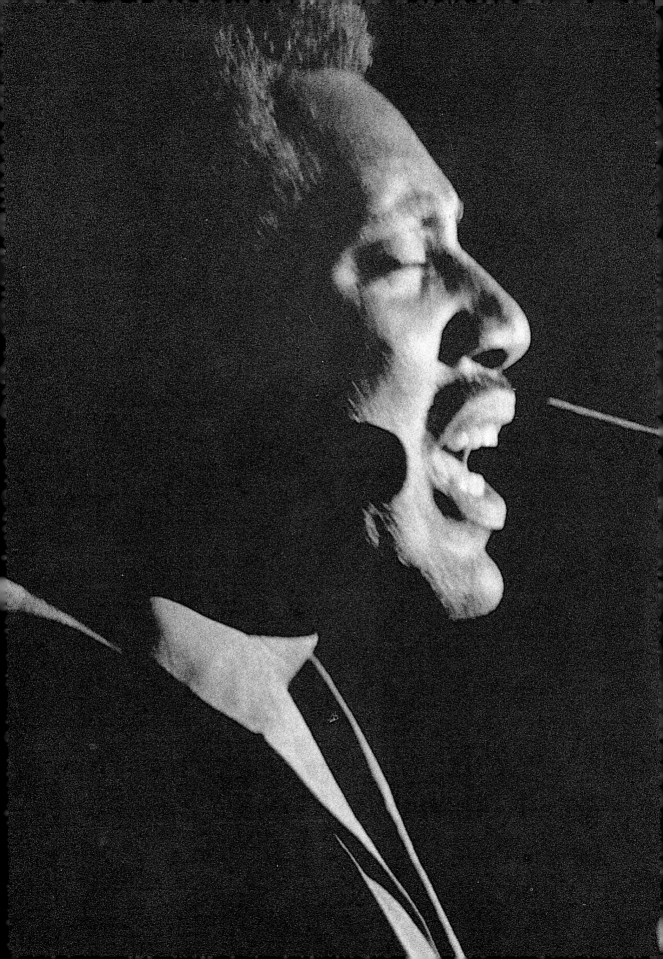

Saturday Night

· · · · · · · · · · · · · · · · · ·

OTIS REDDING
WITH
BOOKER T. AND THE MGS
& THE MAR-KEYS

JEFFERSON AIRPLANE

LAURA NYRO

PAUL BUTTERFIELD
BLUES BAND

THE BYRDS

HUGH MASEKELA
WITH BIG BLACK

MOBY GRAPE

THE CARNIVAL ATMOSPHERE reached its peak Saturday night, when 8,500 people crowded into the arena for the show, the largest audience in the history of the fairgrounds. Police Chief Marinello estimated the crowd on the fairgrounds at 35,000. The Arab League offered exotic falafel, Congregation Beth El sold pastrami sandwiches, and the sign on the soul food booth read, "Man, like this is the scene because if you cats dig soul food, like order, pay, chew. Get with it. This is for the in cause, like do you cats support us?"

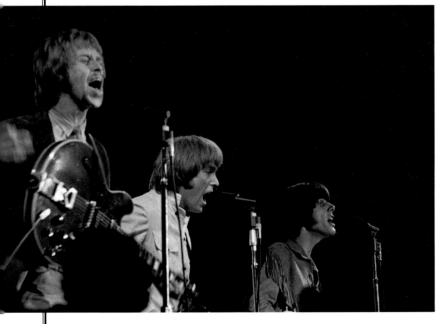

Moby Grape (left to right): Skip Spence, Bob Mosely, Peter Lewis.

THE SUN HAD JUST SET and people were still taking their seats when Moby Grape opened the concert. The band had expected to be appearing later in the program, but the schedule was switched around at the last minute. With all the distractions, the group failed to make a great impression.

Actually, Moby Grape was one of the most pungent, exciting bands from the San Francisco scene. The object of a spirited bidding war between record labels, the Grape had ultimately signed with Columbia Records and recorded a stunning debut album, released two weeks previously, a crisp and biting piece of crafted, driving rock. For their introduction to

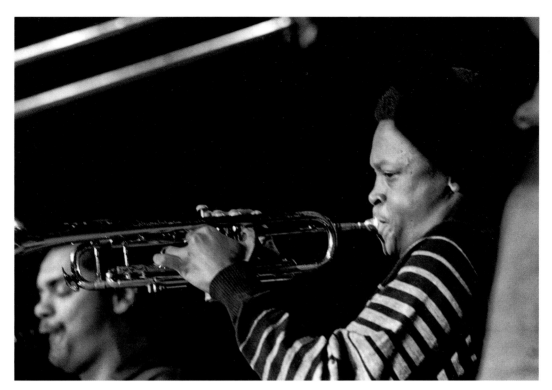

Hugh Masekela: hipster's idea of a jazzman.

the press in a lavish album release party at the Avalon Ballroom, the band had been joined onstage by Janis Joplin, although the triumphant moment was spoiled to a certain degree when band members were arrested later that night in the Marin hills for smoking marijuana.

Built around songwriter Skip Spence, the original drummer with the Jefferson Airplane, the band blasted through tight, cracking songs like "Indifference" and "Fall on You," three guitars leading the charge, voices blending in delicious harmony. Guitarists Spence, Jerry Miller, and Peter Lewis, bassist Bob Mosley, and drummer Don Stevenson rushed through their set, popping off the songs in quick succession, keeping the versions trim and tidy, not stretching them out with solos as they would have at the Fillmore or Avalon.

South Africa–born jazz trumpeter Hugh Masekela, who followed the Grape, might have seemed an L.A. hipster's dream of a jazz musician in his tortoiseshell shades and electric blue pullover, scatting in his native tongue over rolling post-bop cadences. He mixed pop songs such as "Here, There, and Everywhere" and "Society's Child" with African-based pieces like "Bajabula Bonke (Healing Song)" But his tepid solos ran pointlessly on and on, and his fifty-five-minute set, the longest of the festival, went over like lead. Only his showy conga drummer Big Black managed to rouse the crowd.

Unbeknownst to his fellow Byrds, founding member David Crosby had spent the pre-

vious two weeks rehearsing at Stephen Stills' house with the rest of Buffalo Springfield. Neil Young had left that band, and Crosby was preparing to take Young's place and leave the Byrds behind. When Crosby got on stage at Monterey sporting an STP sticker on his guitar—which was not a salute to the automotive fuel additive—and a bad attitude, he thought that very possibly the Saturday night concert would be one of his last performances as a member of the Byrds. It was.

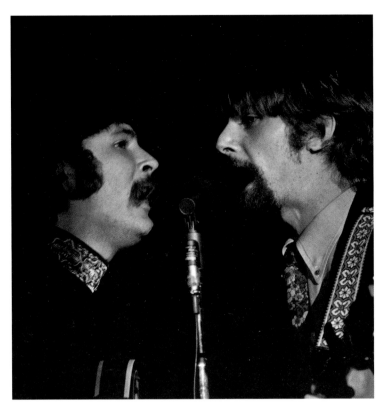

Crosby and McGuinn of the Byrds.

He started out by mentioning recent comments by Paul McCartney that war could be ended if politicians took LSD. "I concur heartily," Crosby said. He was warming up to mischief. He introduced "He Was a Friend of Mine." The song, by Byrds bandleader Jim McGuinn, was about the assassination of President Kennedy. Crosby added his own assault on the Warren Report: "The TV will edit this out," he said, "like they'll cut all the groovy things Country Joe said. But I'm gonna say it anyway: John F. Kennedy was shot from a number of different directions by a number of different guns. The facts have been suppressed, witnesses killed, and this is your country, ladies and gentlemen." McGuinn was furious at the gratuitous remarks.

Perhaps not surprisingly, the Byrds gave a desultory performance—despite a guest performance by trumpeter Masekela and conga drummer Big Black on "So You Want to Be a Rock and Roll Star." The group was undermined by tensions within the band and a prevailing ennui that would culminate with McGuinn and Chris Hillman firing Crosby a few months later. The band would never recapture the commercial heights that brought the Byrds to Monterey in the first place.

The Beach Boys were supposed to have followed the Byrds, but they canceled only

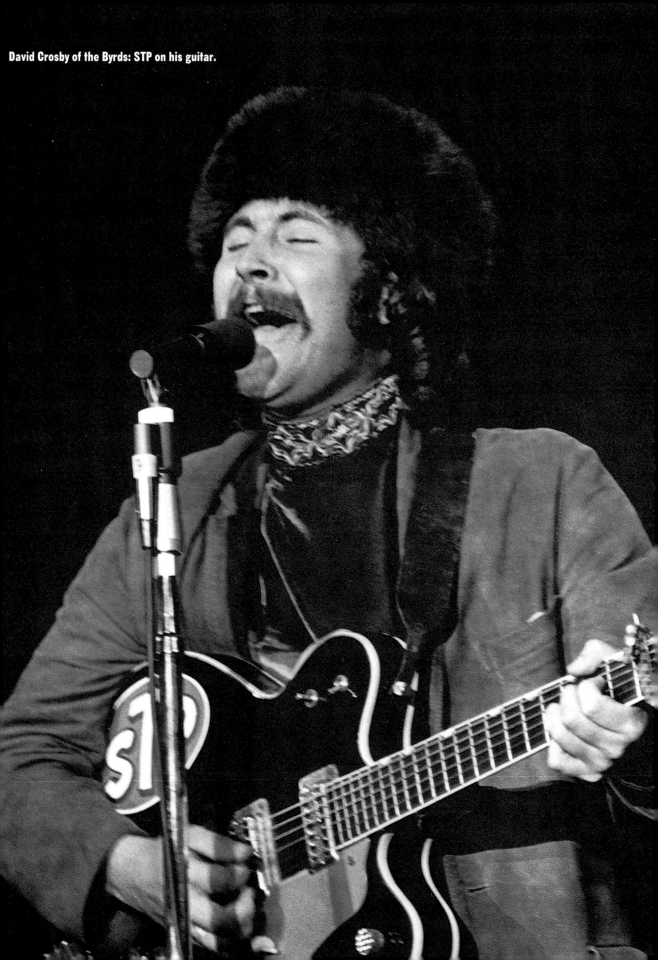

David Crosby of the Byrds: STP on his guitar.

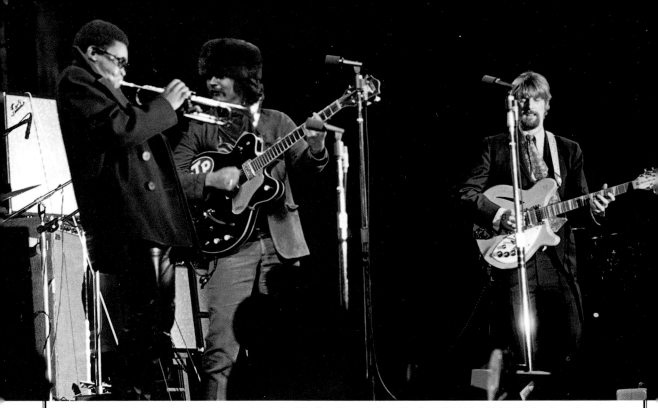

Trumpeter Hugh Masekela joins the Byrds for "So You Want to Be a Rock and Roll Star" (David Crosby and Jim McGuinn of the Byrds).

days before the festival, citing various reasons — all but the real one: the band was afraid to appear at Monterey.

Beach Boys mastermind Brian Wilson, at the time in the grip of a personal crisis of confidence, had scrapped the album "Smile," a work he had spent the better part of the previous year recording. He felt lost, personally and musically, adrift in a world that changed too quickly for him to keep pace. Vocalist Mike Love preferred to be paid when he sang, and some of the other members also voiced misgivings. The obvious but unsaid truth was that the Beach Boys worried about appearing on the same stage with these other, far more hip acts and feared the repercussions. The cancellation was a capitulation. The Beach Boys missed the boat at Monterey; the group was never again anything but an oldies act.

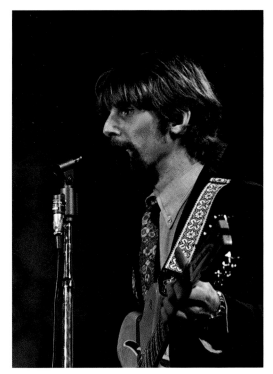

Jim McGuinn of the Byrds: he was furious at David Crosby for his gratuitous remarks.

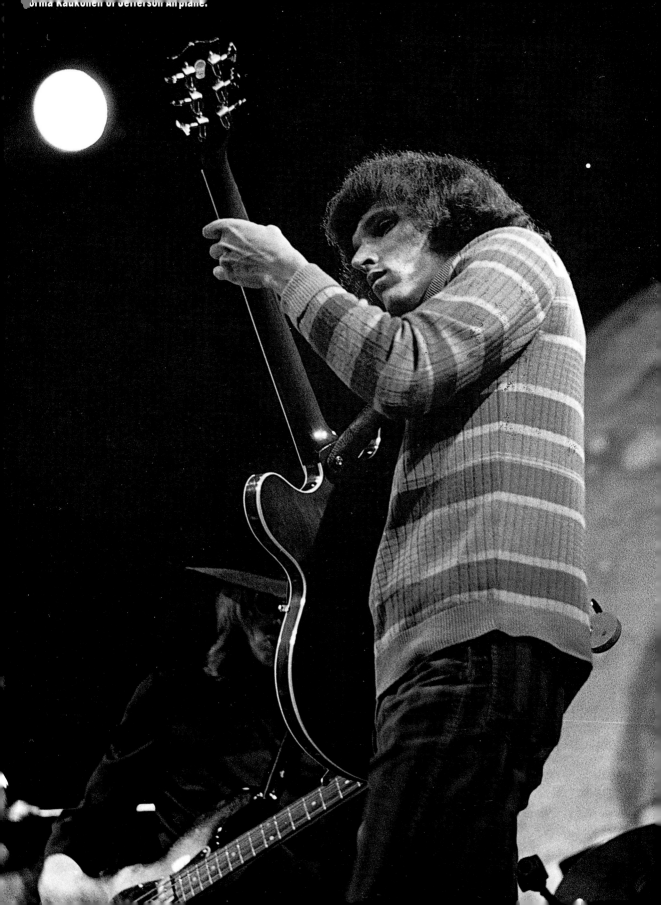

The Paul Butterfield Blues Band took the Beach Boys' place in the program and, surprisingly, played the exact same show the band had performed earlier that afternoon.

That day, Laura Nyro had suffered her first humiliation when she encountered Paul Simon on the festival grounds. "I'm Laura Nyro," she had said, extending a soft hand with long purple nails. "I really love your album."

"Uhmm, OK," said Simon and walked away.

"When people tell me they like my album," she admonished loudly to his back, "I thank them." Then it was her turn to walk away.

Simon can be forgiven for not knowing Nyro; few did at the time. Adler had put her on the bill as a personal pick, a promising bud he thought might bloom on the festival stage. "Wedding Bell Blues" from her debut album of the previous year had garnered some West Coast airplay, but neither the single nor the album even nicked the bottom of the charts. The Fifth Dimension, Barbra Streisand, and Blood, Sweat and Tears would ultimately make big hits out of "Wedding Bell Blues," "Stoney End," and "And When I Die," respectively, off that album. But Laura Nyro took the Monterey stage all but unknown and painfully short of performing experience. It was not a pleasant debut.

After only a brief, cursory run-through with the house band that morning, Nyro was forced to make do with less than sensitive accompaniment from the Hollywood session players. She had brought two background vocalists; and the supper club wardrobe — Nyro wore a black evening gown — hardly helped. Her delicate synthesis of pop and gospel was manhandled by the band. Nyro, making the first important live appearance of her short career, couldn't master the situation. With the audience's hisses ringing in her ears, she ran offstage in tears. Michelle Phillips bundled her off to a waiting limousine, a fat joint, and a can of beer, and the two rode around the misty highways above Monterey for a while.

Jefferson Airplane was the most anticipated act of the

Paul Kantner of Jefferson Airplane.

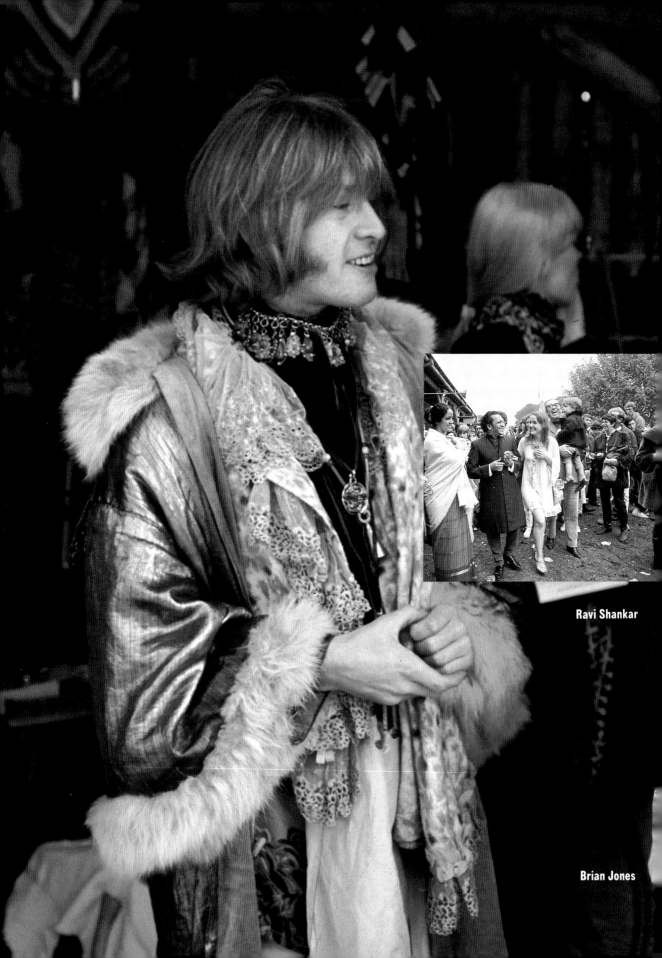

Ravi Shankar

Brian Jones

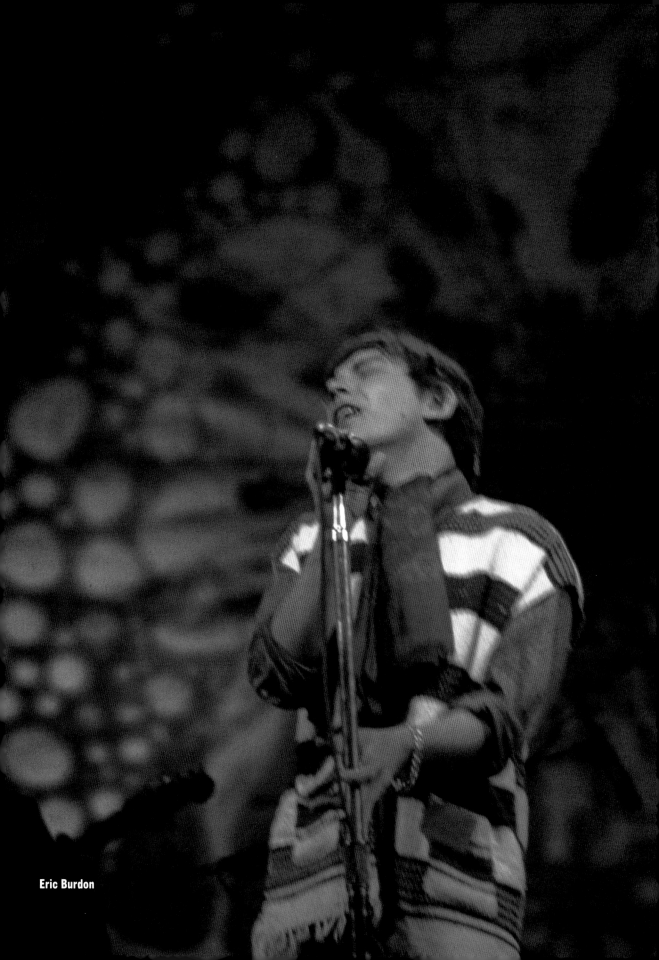

Eric Burdon

Simon and Garfunkel

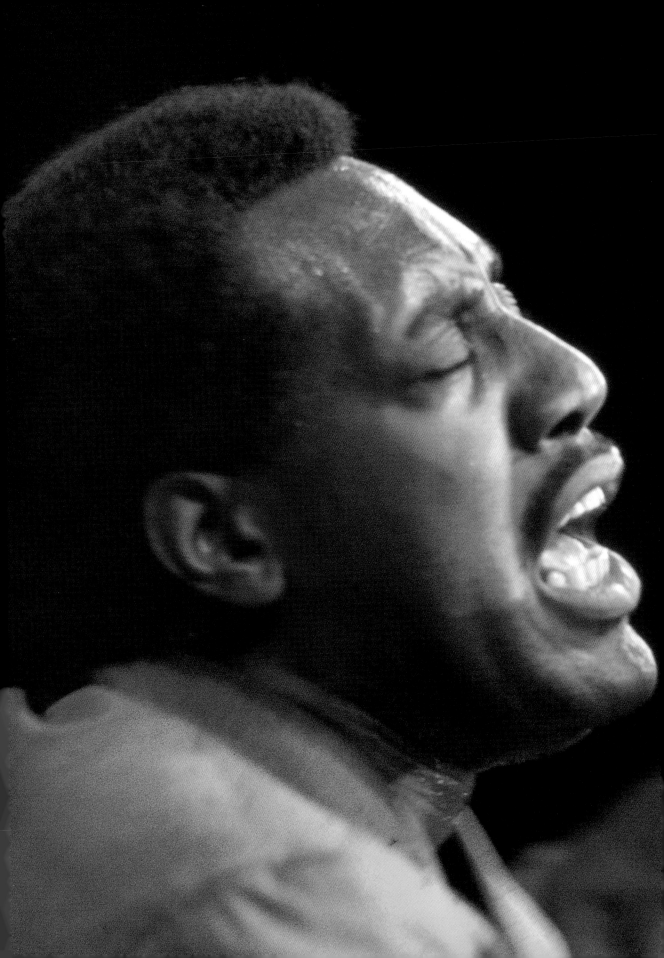

Marty Balin and Grace Slick of Jefferson Airplane.

Otis Redding

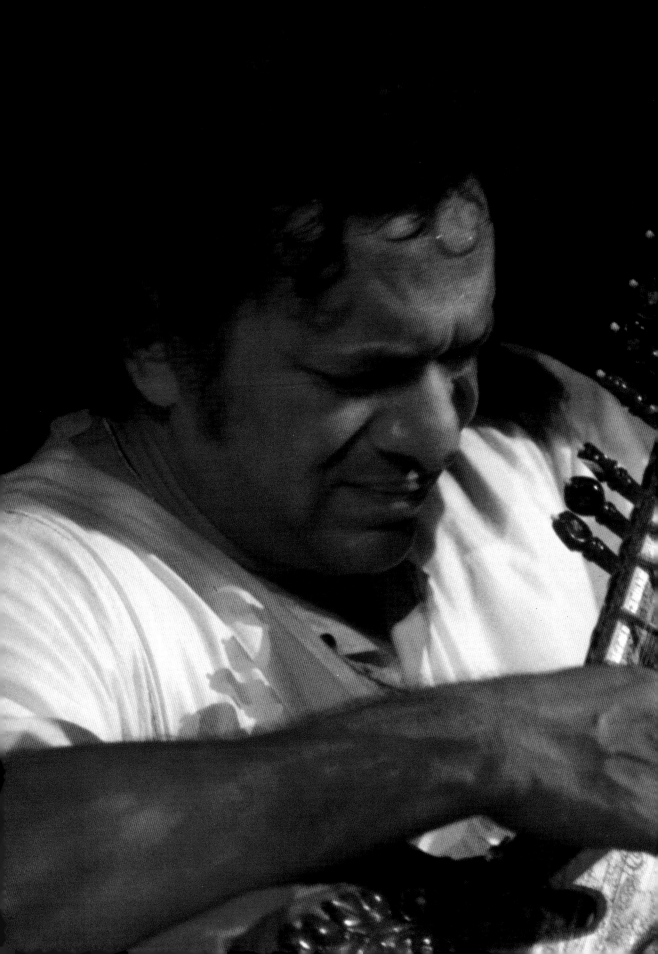

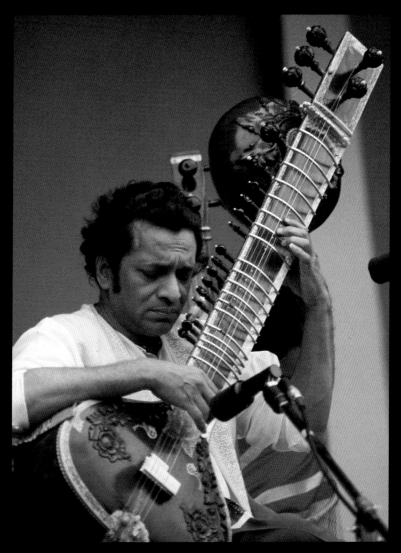

Ravi Shankar

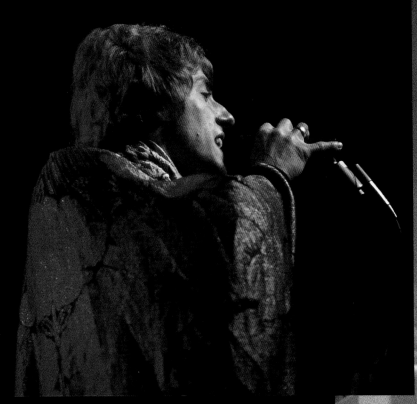

The Who's Roger Daltrey (above) and Peter Townshend
smashing his guitar.

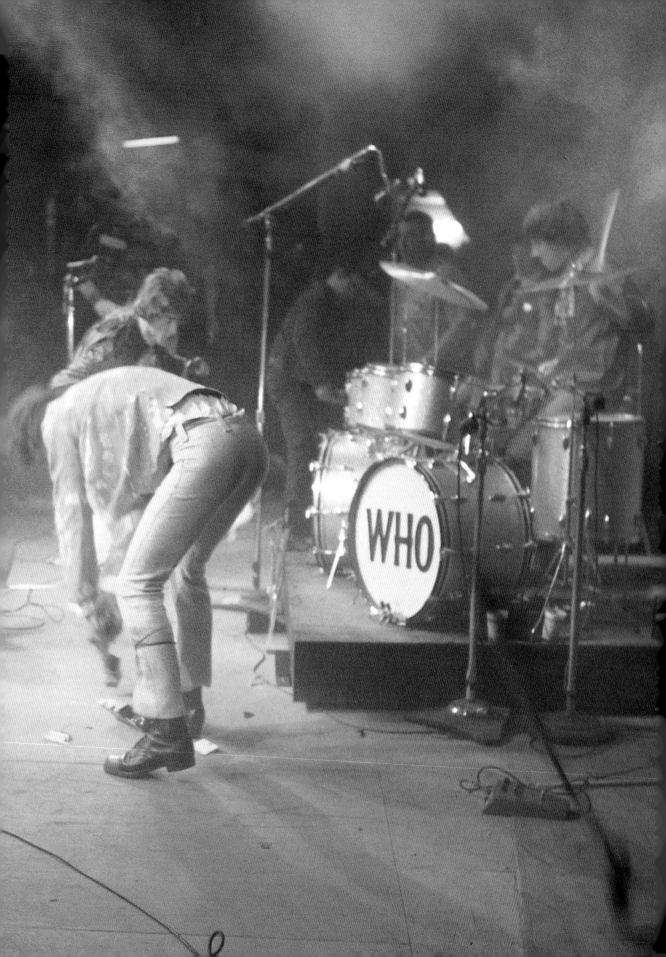

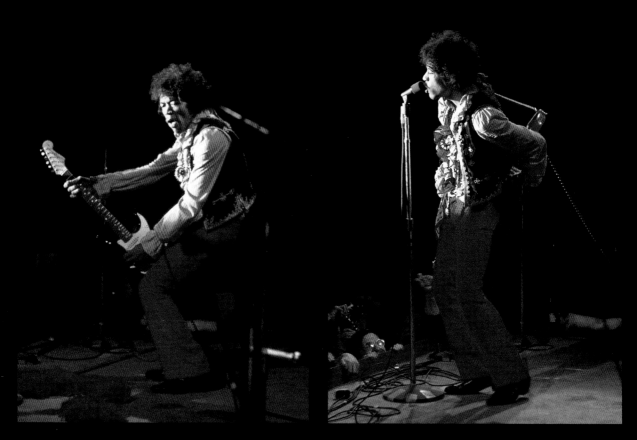

Jimi Hendrix

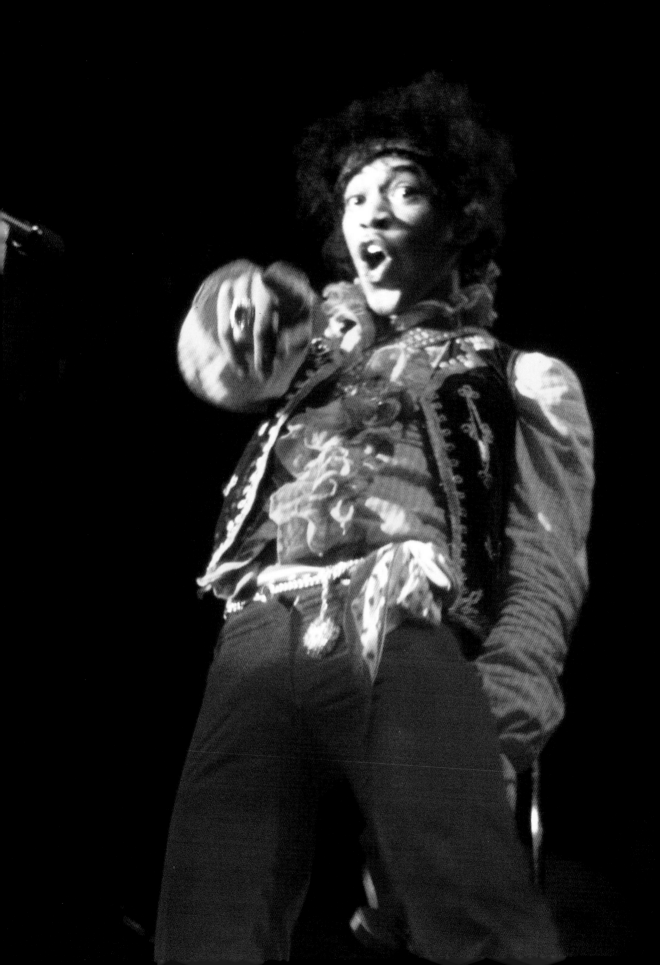

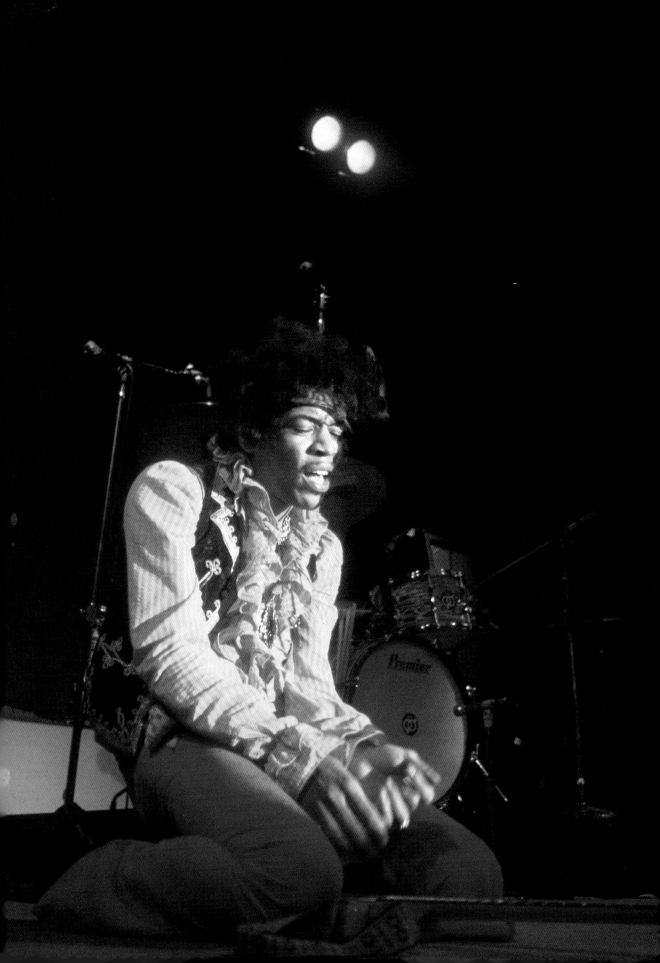

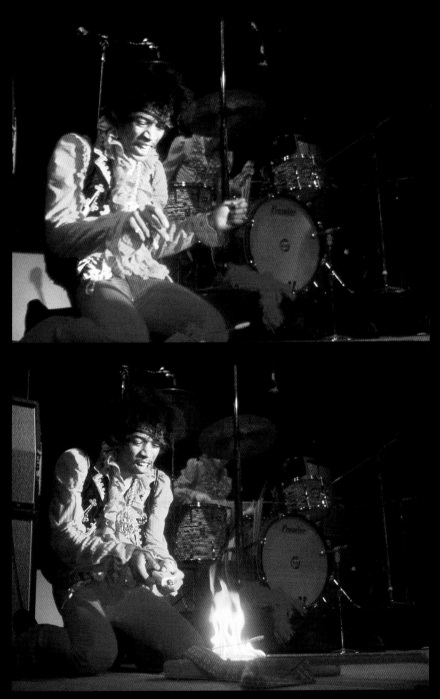

Jimi roasts the Fender.

The Mamas and the Papas

Michelle Phillips of The Mamas and the Papas

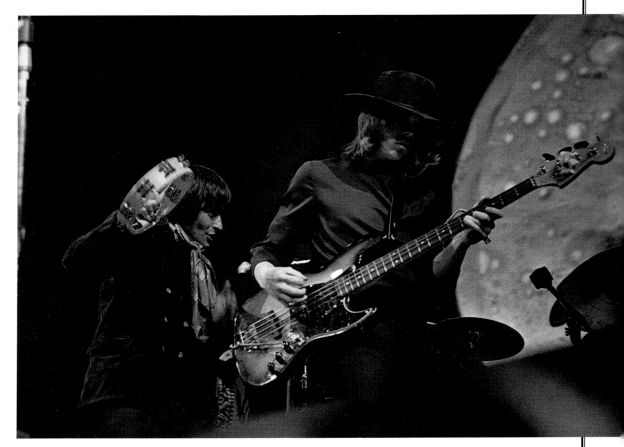

Marty Balin and Jack Casady of Jefferson Airplane.

evening. "Surrealistic Pillow," the band's second album, had cruised into the Top Ten only weeks before, and the first of the album's two hit singles, "Somebody to Love," was one of the most popular records in the country that very week, with "White Rabbit" waiting in the wings.

Even more important, the Airplane was perceived as the spearhead of this new San Francisco sound. The band's original female vocalist, Signe Anderson, had been replaced by Grace Slick, a former model turned hippie queen, both beautiful and talented, the very makings of San Francisco's first rock star. Her soaring voice blended like colors in a sunset with former folksingers Marty Balin, who had first organized the band less than two years earlier, and Paul Kantner. Instrumentally, the songs were supported by the imaginative folk-blues lead guitar of Jorma Kaukonen, the innovative, adventurous bass of Jack Casady, and propulsive drumming by Spencer Dryden.

After spending several days prior to the festival resting at the Buddhist retreat in Tassajara Hot Springs, down the coast from Monterey, the Airplane delivered a spirited forty-

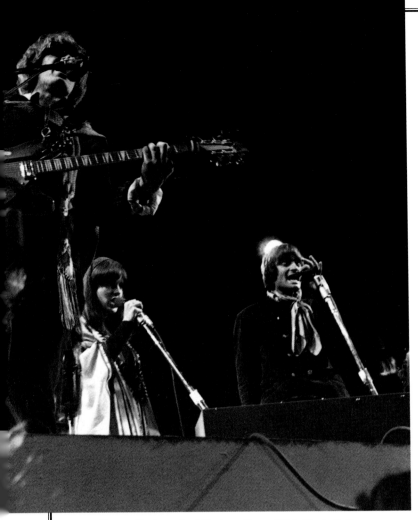

Jefferson Airplane: Paul Kantner, Grace Slick, Marty Balin.

minute performance. Opening with the current hit, "Somebody to Love," they concentrated on material from "Surrealistic Pillow." At the end, the Airplane took a left turn into two new pieces. While "Young Girl Sunday Blues" hardly qualified as a radical departure, "The Ballad of You and Me and Pooneil" ran through several distinct passages, a kind of rock suite that lasted more than eleven minutes. They pasted the parts together with a jumbled jam of fiery ensemble work and stinging Kaukonen guitar.

In the audience, a very anxious Phil Walden sat next to Jerry Wexler of Atlantic Records, getting more nervous with every minute as the Airplane played. He had taken Otis Redding to Europe twice—they had just returned from the most recent trip—with extraordinary success, and Redding had played the Fillmore Auditorium in San Francisco the previous fall for three nights. But Monterey would be the first time the Georgia soul singer had faced a major white American audience. Walden had seen what had happened earlier to Hugh Masekela and Laura Nyro. Had he brought Otis to California to fall on his face?

Walden went backstage and found a relaxed Redding hanging out with his band, Booker T. and the MGs. Customarily, he traveled with a different set of road musicians and only recorded with the MGs—Booker T. Jones on organ, Steve Cropper on guitar, Donald (Duck) Dunn on bass, and Al Jackson, Jr., on drums. But for the recent European tour, where he had recorded a live album in Paris, and the Monterey date, he had brought along the house band from the Stax/Volt studios. Redding had been talking to the group about joining him on the road, even though the record company didn't seem likely to let them leave the studio.

Walden and Redding had been consciously aiming to break into the white market, something no rhythm and blues entertainer had done since the early days of rock and roll. While Redding had developed an enormous following in Europe, where the rootsy, more organic Stax/Volt approach to soul was favored over the slick Motown sound, he was still relegated to an almost exclusively black audience back in the States. But his album sales indicated growing interest in Otis by white fans, who were also beginning to turn up at his shows around the country. Monterey was a crucial part of a master plan, and Wexler had even arranged for Atlantic Records, who distributed the Stax/Volt labels, to underwrite some of the expenses.

The crowd gave the Airplane a standing ovation, calling for an encore, a cry that went unanswered as stage hands cleared the decks for Redding and the MGs. The festival promoters had agreed to a midnight curfew with the Monterey City Council and police. The coach was about to turn into a pumpkin. Backstage, Walden and Phillips helped squeeze Redding into the orthopedic brace he used to restrain his girth. As Booker T. and the MGs took the stage to play a warm-up number, the aisles filled with people streaming for the exits.

Tommy Smothers introduced Otis: "It's been a real groovy day and a great evening, and here, let's bring on with a big hand, Mr. Otis Redding." The stocky black man in the teal-

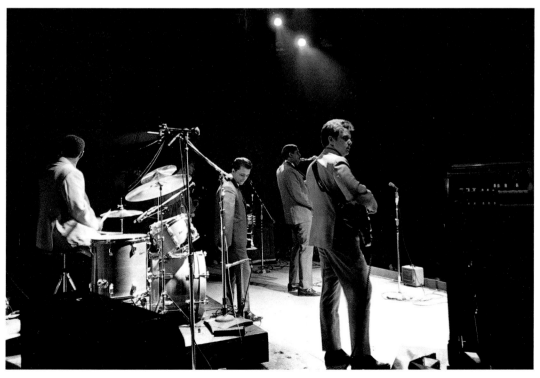

Booker T. and the MGs and the Mar-Keys: waiting for Otis to take the stage.

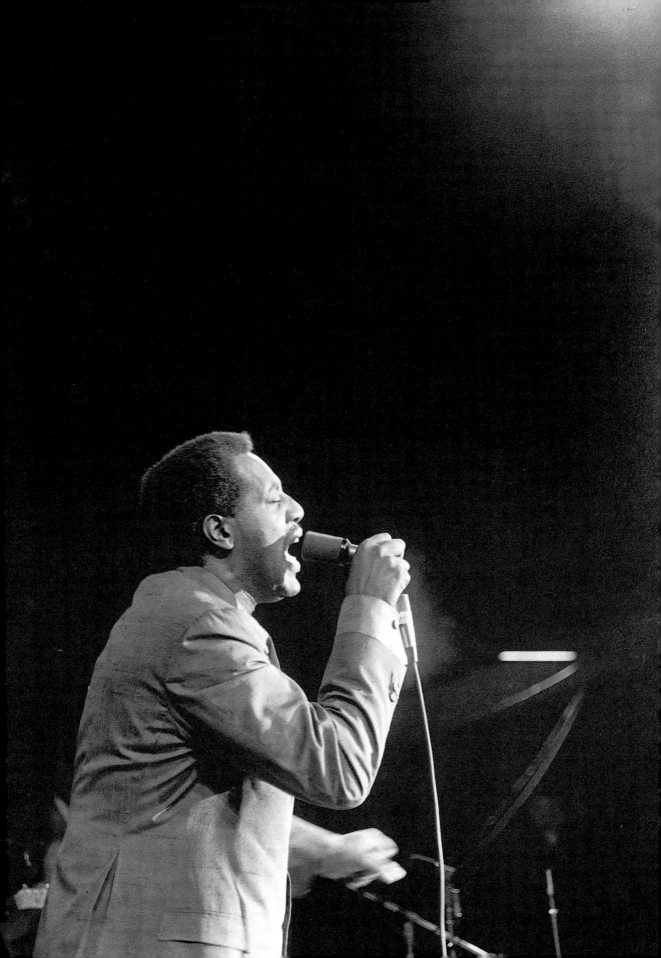

colored suit hit the stage running, letting go a jubilant yelp long before he reached the microphone, as the band and horn section rolled through the introduction to Sam Cooke's "Shake" at nearly double time. Snatching the mike from its stand, Redding cut straight to the song's chorus:

Shake
Everybody say it
Shake
Let me hear the whole crowd
Shake
Everybody say it
Shake
A little bit louder
Shake
Early in the morning
Shake
Late in the evening
Shake
In the midnight hour
Shake
When the time goin' bad
Shake
Shake with the feelin'

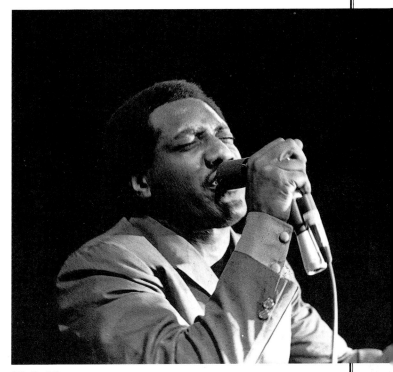

Otis Redding

The blast of pure adrenaline stopped the crowd in the aisles. By the time he brought the speeding freight train of a song to a close, the crowd's full attention was riveted on Redding.

"This girl just took this song away from me," he smiled, "but we're going to do it for you anyway." Aretha Franklin's version of "Respect" would be the number one song in the country the next week, but few in the crowd knew Redding had written and first recorded the song. He used it like a hammer on the crowd's head.

"This is the love crowd, right?" he beamed. "We all love each other, right?"

Redding caught the mood of the audience and began to toy with it, dropping the tempo into his excruciatingly slow ballad, "I've Been Lovin' You Too Long." In the middle of this intensely wrought, aching song, he shrieked and dropped back on the stop-break drumbeat. In the moment of dramatic silence, he turned back to the band and grinned. "Can I have that again, please?" he asked and repeated the move. And then he repeated it again. And then

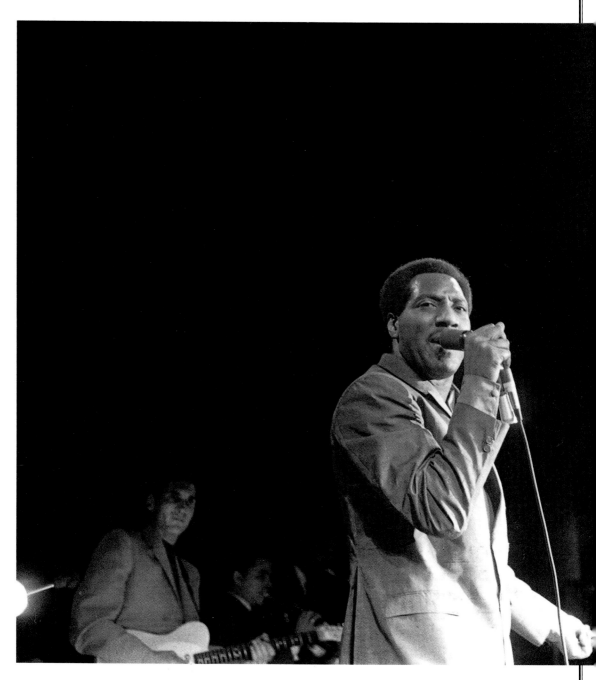

again. He was playing with the "love crowd" now, completely in control, a cat with his mouse.

He turned the heat back up for "Satisfaction," a Rolling Stones song he transformed into something entirely his own without ever learning the words. He dedicated "Try a Little Tenderness" to "the mini-skirts" and brought that number to its explosive, exhausting climax, not once, but twice, and left the stage with the audience more breathless than he was.

In less than twenty minutes on the Monterey stage, Otis Redding wrote his name into history, although he didn't know it at the time. He and Walden rented a car and drove down the coast to Los Angeles the next day, still wondering how well he had gone over. On Monday morning, when he picked up the newspaper and saw he was being called the star of the show, Redding allowed himself a broad grin and a soft chuckle. He did not live to savor the fruits of Monterey very long. Six months later, the twenty-six-year-old soul giant died in a plane crash in the icy waters of a Wisconsin lake.

People slept anywhere they could that Saturday night. Motel beds were full, and even the floors of motel rooms were full. Many people simply unpacked their sleeping bags on the fairgrounds' lawn and slept on the spot. One enterprising local put out a sign reading "Sleep-In" and charged a buck for people to park and sleep in their cars in his empty lot.

But the hard-core troupers headed back to the football field at Monterey Peninsula College, where Danny Rifkin had established his alfresco crash pad for several thousand. A flatbed truck held enough equipment for some anonymous musicians to begin a jam session around two in the morning. Before the makeshift bandstand stretched a sea of sleeping bags. Stoned and spent, people slipped off to sleep as the music continued toward the dawn. At one point, a vocalist with a familiar voice joined the proceedings, and many undoubtedly thought they were dreaming.

They weren't. It really was Eric Burdon.

Sunday Afternoon

· · · · · · · · · · · · · · · · · · ·

Ravi Shankar

Sunday Evening

· · · · · · · · · · · · · · · · · · ·

The Mamas & the Papas

Jimi Hendrix
Experience

Grateful Dead

The Who

Buffalo Springfield

The Group with
No Name

Big Brother &
the Holding Company

Blues Project

ON SUNDAY MORNING, RAVI SHANKAR WOKE UP DISCONSOLATE. During the night, it had rained, and he looked out his hotel window to see that it was still drizzling. The cosmopolitan Indian classical musician had come to Monterey two days earlier and visited the fairgrounds, marveling at the colorful youth and listening to some of the rock music. He was anxious to participate in the event, although nervous about how he would fit in among all the pop groups.

Ravi Shankar backstage: Augustus Stanley Owsley watches Shankar greet a well-wisher.

SINCE GEORGE HARRISON HAD TRAVELED TO BOMBAY THE previous fall to study with this master of the sitar, Ravi Shankar had experienced a prominence he had never previously achieved during his many years as India's leading cultural export. None of his associations with the famous figures of the classical music world—Yehudi Menuhin, Pablo Casals, Andrés Segovia—brought him the honor that he now had as guru to the earnest Beatle. Harrison had introduced the sitar into Beatles recordings such as "Norwegian Wood," "Love You Too" and "Within You Without You" from the new "Sgt. Pepper" album. It was an unexpected door to a new audience that Shankar now faced in Monterey.

Shankar was a part of the original Shapiro-Pariser festival, and the only Monterey artist to be paid; Phillips and Adler had honored his contract which called for a $3,500 fee. He had already met Brian Jones over the weekend. The Rolling Stone, dressed in peacock finery and almost reverentially respectful, had mumbled his awestruck appreciation of Shankar's art. To an uncomfortable Shankar, the obviously stoned young man was a pitiable wretch; Shankar strongly disapproved of drugs and found the connection between Indian music and psychedelics more than slightly distasteful. He did not relate well to rock and roll

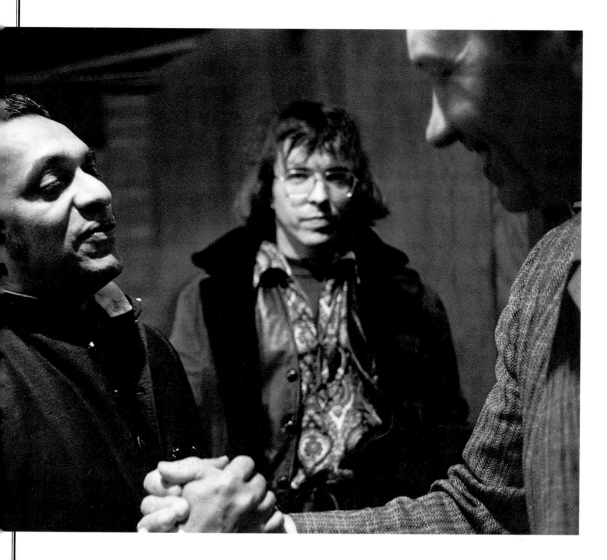

and looked patronizingly on efforts to use the sitar on records like "Paint It Black," where an untrained Jones picked out a simple, repeated riff on the complex stringed instrument.

But throughout his career, the forty-seven-year-old musician had been devoted to exposing the broadest possible audiences to Indian classical music. He had taught courses at American universities on both coasts and saw Monterey as an unparalleled opportunity for his crusade. Now, as he watched the overcast skies, he worried that his show would be canceled or the weather would keep the audience away. He waited and hoped.

The skies stayed gray, but the rain stopped. Shankar took the flower-festooned stage about fifteen minutes after the scheduled 1:30 p.m. start. With him were two colleagues, Alla Rakha—a musician of the same stature as Shankar in Indian music circles—on tabla, and Kamala on tamboura. An electric heater sat close behind the three musicians on the raised

platform in the center of the stage.

"Let us all pray," said Shankar, "that I can give a good performance to you and that it doesn't rain." He tuned his instrument—for the sitar, a process that consumes considerable time. The crowd gave him a big round of applause, enthusiastic but naive. What followed was one of the most extraordinary moments of cross-cultural harmony in the annals of pop music. Shankar would always consider it one of his finest performances.

For more than three hours, Shankar held the audience pin-drop quiet, as he spun the improvisations of his ragas with crystalline purity. He drew them into his spell. He complimented the audience on their choice of incense and joss sticks. He threw the orchids they heaped upon him back into the crowd. He played the crowd like an instrument. "I love all of

you," he told them, "and how grateful I am for your love of me. What am I doing at a pop festival when my music is classical? My music may not be pop music, but I hope it can be popular. I knew I'd be meeting you at one place, you to whom music means so much."

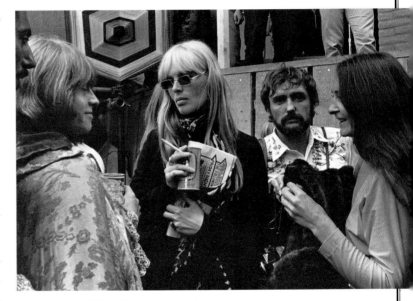

Brian Jones and Nico (Dennis Hopper in background).

He began with a rather simple but flashy raga. The broadcast over loudspeakers through the festival grounds began to draw people. Before long, he had a full house. In the audience, Jimi Hendrix nodded appreciatively. Mike Bloomfield sat rapt on the side of the stage. Shankar geared his inventions to suit the crowd. Long improvised instrumental solos were a critical part of the San Francisco rock scene, and Shankar was playing on that appeal, presenting them to the guitar solo's cousin from the East. He built to a fleet-fingered finale, with a rapid exchange of volleys between Shankar and Alla Rakha on tabla, an almost intuitive rapport between musicians that left the audience hypnotized. When Shankar was done, they exploded in applause and stood, cheering, for five full minutes.

Brian Jones wandered the fairgrounds like a prince among his subjects. He strolled without incident or consternation, beaming through the fog inside his head, often in the company of Andy Warhol actress and singer Nico. Barry Melton of Country Joe and the Fish

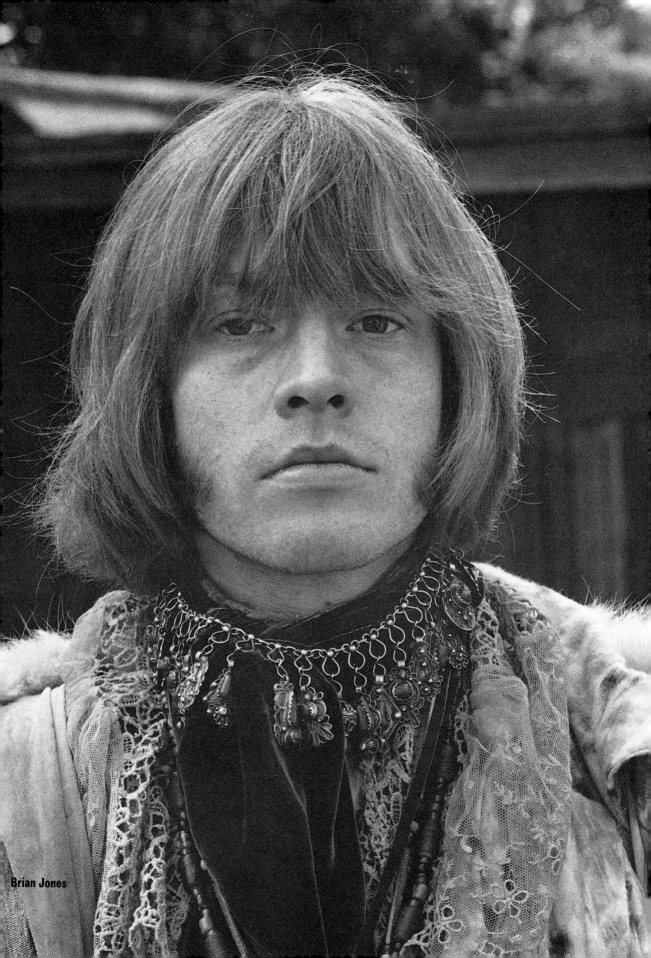

Brian Jones

watched in amazement as Jones dipped into the pockets of his wondrous garments, which seemed to grow more exotic as the weekend progressed, producing another pill every fifteen minutes or so and gulping them down as though they were medicine for a very sick man. Melton asked Jones what the pills were. "Let me see," Jones mumbled, checking his pockets. "Left side is up, right side is down."

Rumors ran rampant all weekend that the Beatles would show. Comedian Tommy Smothers, working Saturday night as emcee, teased the crowd about the supposed appearance. Finally, Derek Taylor, besieged by the questions, broke down. They're here, all right, he told the Sunday afternoon press conference, only they're disguised as hippies. Not everybody understood his sarcasm; the Los Angeles Times reported the Beatles-as-hippies sighting as fact on Monday morning.

Taylor took the opportunity of the press conference to bestow on Police Chief Marinello a necklace, as Adler looked on smiling. "Now you're one of us," Taylor told the chief. A veteran of thirty-three years on the force and deputy chief for thirteen years, Marinello had assumed the chief's job in 1963. He was disarmed by the festival crowd, who covered his officers' motorcycles in garlands and happily termed the cops "flower fuzz."

"I have been through nine Jazz Festivals," he told the press conference, "and when I was told that this would be five times as large, I was flatly opposed to it. We have 30,000 citizens in Monterey and forty-six regular officers, and the festival people were talking about an influx of three or four times our population.

"From what I've seen of these so-called hippies," he continued, "I have begun to like them very much. I've even made arrangements to be escorted through Haight-Ashbury district by some of my new friends."

Dionne Warwick was supposed to open the Sunday night show. She was to

"Flute Thing": Andy Kulberg of Blues Project.

have flown down from San Francisco, where she was appearing at the Venetian Room, the posh supper club at the Fairmont Hotel. A police escort was planned to rush her back after the performance to the Monterey airport, where she would be whisked back to San Francisco in time for her early show on Nob Hill. But the Fairmont refused to allow her to leave. She briefly considered sneaking off and doing the Monterey performance anyway, but decided finally to stay in San Francisco. The Impressions were also scheduled for the closing show, but the rhythm and blues vocal group also canceled.

While both Warwick and the Impressions would have added to the

Danny Kalb and Andy Kulberg of Blues Project.

number of blacks appearing at the fest, neither would have broken through to the audience any more than Lou Rawls or Hugh Masekela did. The rock crowd at Monterey was primed for visceral performers like Otis Redding (or Janis Joplin), and neither the smooth vocal stylings of Burt Bacharach songs being sung by Warwick nor the supple harmony blend of the Impressions could have provided the needed wallop.

That left it to the Blues Project to open the show. Bassist-flautist Andy Kulberg thought the band, one of the first to emerge from the New York underground, was probably on its last legs, and he was already eyeing California as a place to live. Keyboardist Al Kooper had appeared the day before at the festival, using some of his Blues Project songs in his own repertoire. Vocalist-keyboardist John John McDuffy had been added to replace Kooper, but the band was not feeling all that confident.

At sound check, Kulberg had watched Buffalo Springfield and had been blown away at the level of musicianship. When the musicians proved not to be very friendly, his feelings of insecurity only increased. The band tossed off a routine performance—Kulberg trotted out his standard "Flute Thing"; guitarist Danny Kalb, flying on Owsley's Purple, dedicated the song "as always, to peace and an end to this dirty, dishonorable war"—and then they left immediately by car for San Francisco to lick their wounds and laugh it up at a performance by the improvisational theater group the Committee.

Tommy Smothers returned Sunday as host of the proceedings. He said he missed his brother. "It's hard working without a straight man," he told the crowd, "and nobody here is straight."

Janis Joplin had awakened that morning in a rage. She and the other members of Big Brother had conducted a band meeting the previous afternoon, without manager Julius Karpen, to discuss his refusal to allow the band to be filmed. After making the splash of the afternoon, with many people proclaiming Joplin a star-in-the-making, the band—especially the combustible Texas vocalist—insisted that the decision be reversed.

Janis Joplin

The band members informed Karpen that they wanted to accept Adler's offer of an encore performance on Sunday night, specifically to have the performance filmed for the TV special. Karpen could only go along. After all, he really only worked for the band; it was their decision.

Janis and Big Brother took the stage to repeat about half the performance that had torn up the crowd Saturday afternoon. Although the band only mustered a fraction of the intensity of the earlier show, Janis and the musicians got their point across, especially on the all-important "Ball and Chain," already clearly the most emotionally explosive single performance of the festival and, this time, captured on film by Pennebaker and crew.

With Paul Simon bringing Beverly to the festival lineup and Adler putting Laura Nyro on the bill, to follow the truncated Big Brother reprise, John Phillips added The Group With No Name as his unknown talent selection, a band that would pass immediately back into oblivion after its half hour on the Monterey stage. But Phillips and his wife were close friends with vocalist Cyrus Farrar and his wife. Farrar had belonged to a defunct group called the Modern Folk Quartet, which had made a couple of regulation folk-singing albums before falling in with producer Phil Spec-

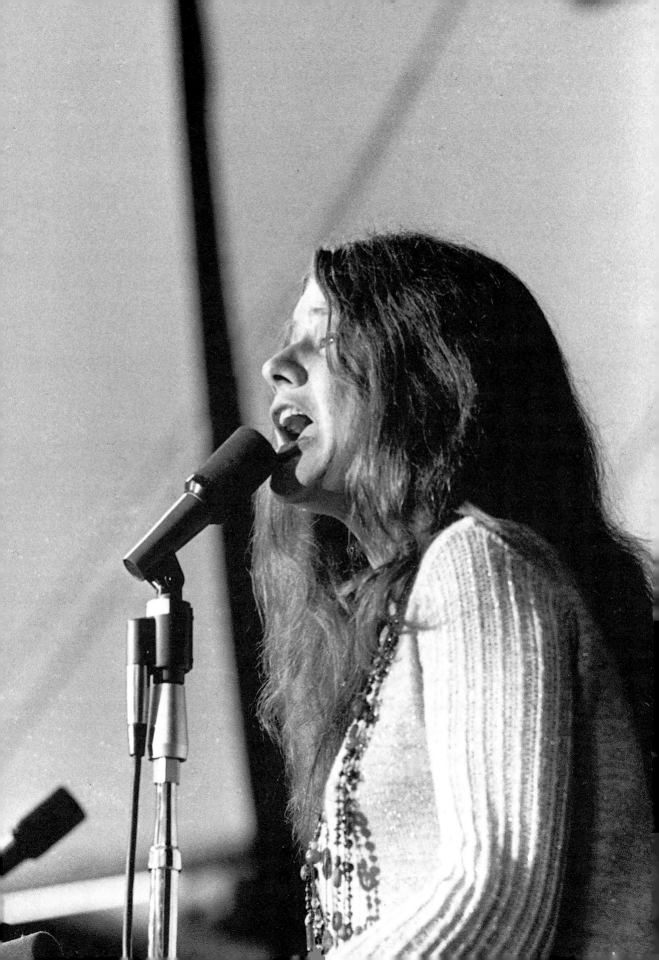

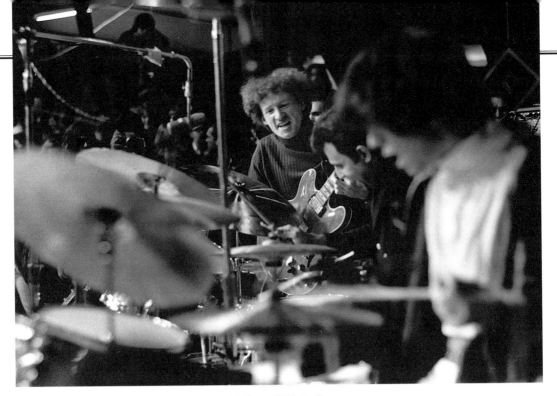

Session drummer Hal Blaine (center) sits in with Group With No Name.

tor. House band drummer Hal Blaine, veteran of thousands of Hollywood recording sessions and many hit records, sat in with the band in an otherwise entirely unmemorable set.

Neil Young had quit the Buffalo Springfield only weeks in advance of the festival, on the night before the group was scheduled to leave for New York to appear on "The Tonight Show." Doug Hastings from the Seattle rock band Daily Flash had been recruited on guitar. And, of course, David Crosby had been rehearsing in secret with the Springfield for the past couple of weeks, preparatory to leaving the Byrds and joining the Springfield. It did not help strained relations in the Byrds for Crosby to take the stage with Springfield at Monterey.

Opening with "For What It's Worth," the Stephen Stills hit from earlier in the year, the band flexed four-guitar muscle during a set that included "Nowadays Clancy Can't Even Sing," "Rock and Roll Woman," and a raucous, ripping "Bluebird."

Backstage, Pete Townshend of The Who angrily confronted Jimi Hendrix. He accused Hendrix of stealing his act, and the two argued about who would follow who. Townshend was still smarting from the experience of having followed Hendrix earlier in the year at London's Saville Theatre. Phillips resolved the matter with a flip of the coin, and The Who went on first.

"I promise you this group will destroy you in more ways than one," said Eric Burdon, introducing The Who, a band for the most part unknown in the States. The only previous American performance by The Who had been earlier in the year at New York's RKO Theater on a Murray the K package show. Although almost every single by the band went to the

Top Ten in England, the records barely dented the charts in this country.

Light applause greeted the band. Guitarist Townshend slammed into "Substitute," one of the band's earliest British hits, his arm windmilling the crashing chords. The mini-opera "A Quick One" followed and then "Happy Jack," the only thing even resembling a U.S. hit. The band introduced the next single, "Pictures of Lily," and the old Eddie Cochran rock and roller, "Summertime Blues," Townshend shattering the rhythm with the slashing, driving chords. But the audience remained unstirred.

"This is where it all ends," announced Townshend. "This is one called 'My Generation,'" chimed in fringe-draped vocalist Roger Daltrey. The song's aggressive, almost hostile stance — "Why don't you all just f-f-f-fade away" — seemed at odds with the professed sentiments of what Redding called "the love crowd." Townshend underlined the song's lyrical message with guitar playing that sounded like a street fight, punctuated by haymaker drumming from Keith Moon.

With the guitar roaring of its own accord, smoke bombs went off at the rear of the stage, the clouds obscuring the psychedelic light show. Townshend stood like a crane, his arms outstretched, guitar swinging in front of him. He sawed the strings against the mike stand, took off the strap and flipped the guitar around over his head. Then, suddenly, violently, he began to smash the instrument against the stage like a sledgehammer. He knocked over a mike stand, and a stagehand, racing to preserve the equipment, nearly lost his head to Townshend's guitar. Having broken off the body of the guitar, the neck still in his hands, he turned

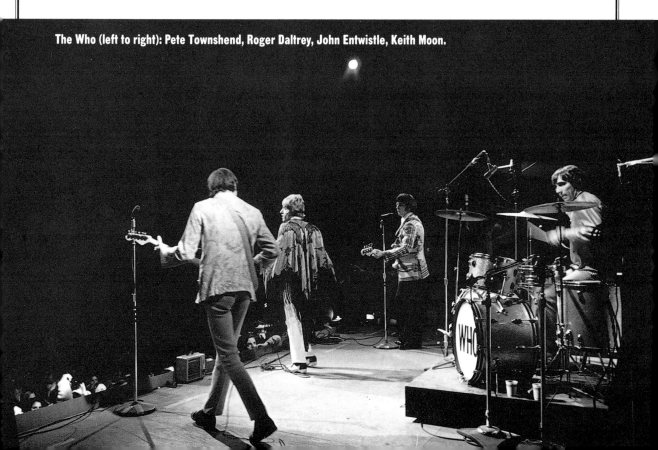

The Who (left to right): Pete Townshend, Roger Daltrey, John Entwistle, Keith Moon.

his attention to the amplifier, alternately chopping at it and ramming it.

As suddenly as the carnage began, it was over, Townshend dropping the remains of his guitar and walking offstage, leaving Keith Moon standing behind his drum kit to kick over the bass drum, while Lou Adler raced from the wings to save what he could. A panic-stricken Wally Heider snatched microphones. The audience went nuts.

The real mopping up chores were left to the Grateful Dead, thrust between The Who and Hendrix, with barely enough time to get warmed up, let alone engage in the subtle alchemy that had made the band a preeminent fixture at the San Francisco ballrooms.

"You know what folding chairs are for, don't you?" said guitarist Bob Weir. "They're for folding up and dancing on." As the band began to play, people hanging out in the wings and behind the amplifiers began to dance, slowly making their way toward the center of the stage. People in the audience picked up the cue and got up to dance. Adler himself helped the stagehands clear the dancers offstage, and the ushers did the same in the aisles.

All weekend long, the Beatles rumors continued. Now, with the end of the event at hand, some fans were trying to find a way past the backstage fence to locate their idols in the elite lair of the stars.

For some reason, the counterfeit Beatle, Peter Tork, was sent to interrupt the Dead set and deny the rumors. "People," Tork said, "this is me again. I hate to cut things down like this, but, uh, there's a crowd of kids—and this is to whom I'm talking mostly; to whom, are you ready for that?—and, um, these kids are like crowding around over the walls and trying to break down doors and everything thinking the Beatles are here . . ."

It was more than Phil Lesh could take. The twenty-nine-year-old classically-trained bassist and designated the band's hard-ass watched this plastic, square, contrived teen idol sent to be the mouthpiece of Lou Adler. Everything Lesh hated was standing right in front of him, interrupting his show.

"This is the last concert, why not let them in anyway?" Lesh asked.

"Um, last concert, all right, except that they're trying to break things down, crawling over ceilings and walls and, like, they think the Beatles are here and they're not. You, those of you, they can come in if they want."

"The Beatles aren't here," said Lesh. "Come in anyway."

"Uh yeah," said a sheepish Tork, "there's great things happening anyway."

"If the Beatles were here, they'd probably want you to come," said Lesh.

"Yeah, except that, uh, just don't, you know, bring down ceilings and walls and everything and, uh, carry on."

The cheers were for Lesh, and Tork knew it. As he crept off, crowds of non-ticket-holders pressed through the arena's rear gate and filled the aisles. The "Seat Power" people

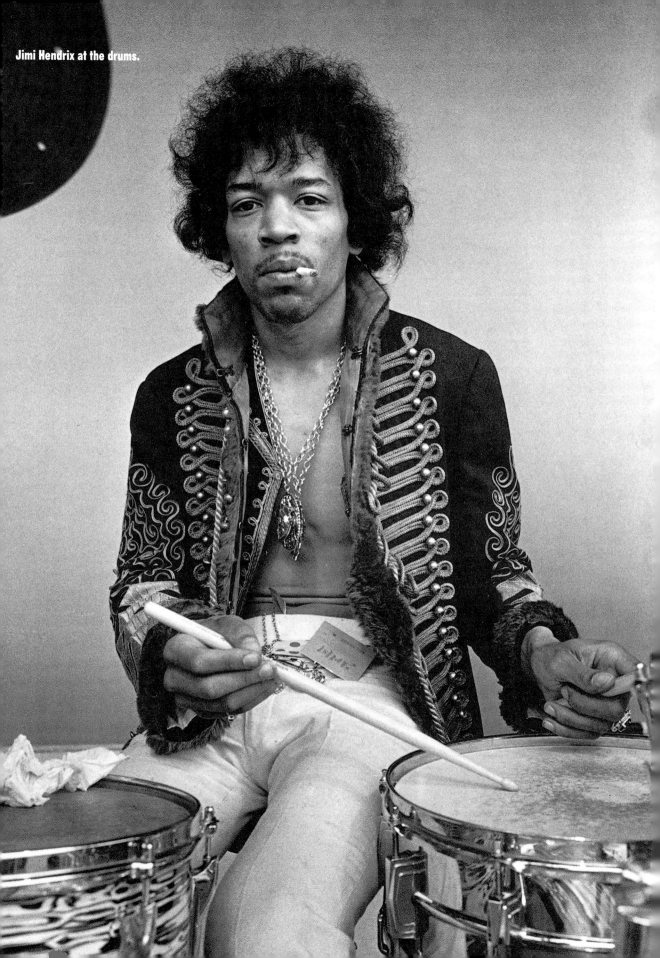

Jimi Hendrix at the drums.

Barry Melton (in army jacket) of Country Joe and the Fish; Mama Cass and friends watch sound check.

stepped aside, and the Dead, inspired by the minor victory, launched a rollicking "Viola Lee Blues," a ten-minute rampage with guitarists Weir and Jerry Garcia trading licks in some of the festival's most impassioned playing.

The night before, Eric Burdon had stopped by the motel where he was staying and found Jimi Hendrix kneeling on the floor, several guitars spread in front of him, paint box open and brush in hand. He is like a warrior before the hunt, Burdon thought. As they puffed on a joint, Hendrix painted flowers and other designs on the four Fenders and chatted with Burdon.

"You know, I hear they printed up a different color tab of acid for every night of the week," he mused, "but there's only three nights here, right, so they got three colors: red, blue, and purple. Pretty far-out, huh?"

Burdon agreed and wandered off into the night. The next time he saw Hendrix was the following night at the backstage cafe. Nearby sat a wide-eyed Buddy Miles; Hendrix's bandmates, Noel Redding and Mitch Mitchell, had also joined the table. As Burdon walked past, Hendrix muttered.

"Purple," he said

Later, Burdon found Hendrix, reeling under a double dose of Monterey Purple, downstairs below the stage, sitting in the small area reserved for musicians. He was plugged into a small amplifier and had a burning cigarette stuck in the neck of his guitar. His fingers flitted up and down the fretboard, playing a riff that never ended. Buddy Miles began keeping time by clapping his hands. Drummer Mitchell began tapping his sticks against the wall, as the music took over the tiny chamber. Bill Graham stuck his head inside. "Hey, shut the fuck up," he snapped. "We can hear you through the stage floor."

Brian Jones made his first appearance on the festival stage to introduce Hendrix. His voice a timid whisper, his face a waxy mask, the Rolling Stone murmured his announcement: "I'd like to introduce a very good friend, a fellow

countryman of yours . . . he's the most exciting performer I've ever heard, the Jimi Hendrix Experience."

Hendrix careened onto the stage, a vivid flash of ruffles, feathers, silk, and bright colors. He smiled and his fingers found the strings of his guitar. The bass and drums fell in behind him, and he started to make the guitar emit little anguished squeals, as he reached the crescendo and started to sing the old Howlin' Wolf blues "Killing Floor" in electric hyperdrive.

His casual vocal style was juxtaposed against the heart-racing guitar sound, notes raining out of his amplifier, Hendrix pausing only to let a sustained tone ring, filling the air like a billowing cloud. His tongue fluttered between his teeth to underline the hammered notes. Nobody had ever seen anything like it. Nobody had ever heard anything like it.

He flipped the guitar between his legs during the solo on "Foxy Lady," lest anyone miss his intent. He announced songs in a soft, almost ladylike voice, jokingly introducing bassist Noel Redding as "Bob Dylan's grandmother," as he rolled into a lucid, glassine riff to open his version of Dylan's "Like a Rolling Stone." He switched back to amphetamine-powered blues drive, warping B. B. King's "Rock Me Baby" into the second half of the twentieth century — "The words may be wrong, but that's all right," he said.

In case the point had not been made, his "Hey Joe," light years away from the version

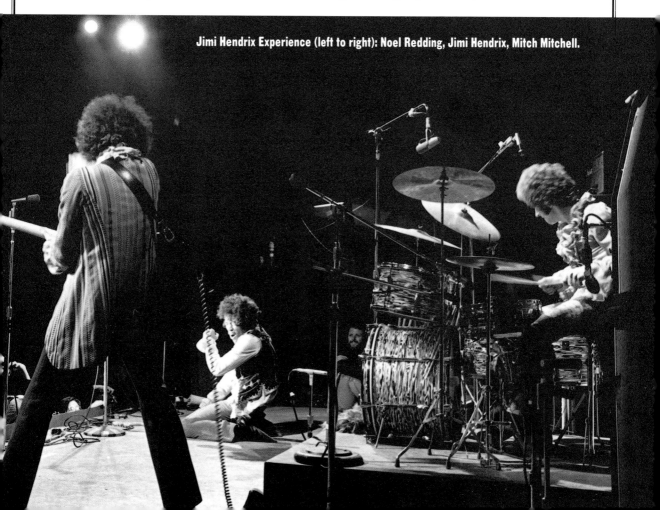

Jimi Hendrix Experience (left to right): Noel Redding, Jimi Hendrix, Mitch Mitchell.

the Byrds had performed only the night before, ricocheted into the night, Hendrix nailing home the final passage with a thumping riff and a humping hip. He dropped the tempo for his ethereal "The Wind Cries Mary" and fumbled his way through the spacey, acid-laced "Thank you—thank you—thank you" before playing "Wild Thing" and setting fire to his guitar.

He stumbled offstage and collapsed into the waiting arms of Brian Jones. Hugh Masekela shouted, "You killed them! You killed them!" Nico rushed up with a hug and a kiss. Bill Graham was talking in his ear. Masekela kept repeating himself, like a mantra: "You killed them . . . You killed them."

After that, the Mamas and the Papas were not so much a comedown as a feathery pillow to fall back on. With John Phillips wired to his teeth and Denny Doherty's having awakened that morning in the Virgin Islands and having pulled into the festival in a red Cadillac convertible just minutes ahead of the group's scheduled performance, their making it to the stage at all must count as a minor miracle. The group hadn't worked in a long time But the ebullience of new mother Cass Elliott settled all the disharmony and tensions between them once they got onstage together.

They opened with "Straight Shooter" and "I Got a Feeling." "Boy, hasn't this been something," Cass beamed to the crowd, "something we can all really be proud of, everybody. It's been so groovy. Yesterday, we were walking along, looking at the jewelry and the booths, and everything was so quiet and peaceful, such good vibrations. We put everybody who thought this would go off badly uptight and let's thank God for that.

"We're going to have this every year, y' know. You all can stay if you want. I think I might. This is a great dream come true.

"And we get to close this out because we're the tallest. Well, John's the tallest and I'm the heaviest. Except me and Pig Pen keep getting mistaken for one another. I keep telling them I'm the one with the tattoos, so they can tell us apart."

They looked like figures out of King Arthur's court. John Phillips wore a fur hat and strummed a twelve-string. His wife Michelle was dressed like a courtesan from Arabian Nights. Mama Cass wrapped herself in chiffon, and Papa Denny came covered in a coffee-colored caftan. Road manager Peter Pilafian, having worked himself dizzy over the weekend as co-producer, took a violin solo during the ragged version of "Spanish Harlem" that followed "California Dreamin'," the song that started it all for the group.

Phillips couldn't resist bringing out his old friend Scott McKenzie to sing the song Phillips had composed seemingly with this moment in mind: "San Francisco (Be Sure to

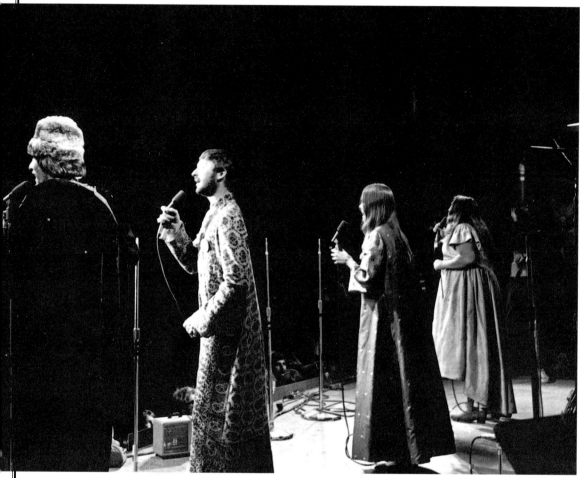

The Mamas and the Papas (left to right): John Phillips, Denny Doherty, Michelle Phillips, Cass Elliott.

Wear Some Flowers in Your Hair)." Country Joe McDonald, still tripping, looked aghast. "We've been had," he thought. For a moment, it looked to McDonald and others in the crowd as if the entire three days had been an elaborate buildup to Phillips' latest chart entry, although the band mangled the song horribly. Many of the San Franciscans in the arena felt like patsies being manipulated by this Hollywood hippie.

The Mamas and the Papas returned, whipped out a big hit, "Monday, Monday," and a rollicking, kicking version of "Dancin' in the Streets," took a couple of bows, and drew the festival to a close with instrumental exit music that would not have been out of place in a Vegas show.

Michelle Phillips came offstage and burst into tears. After all the weeks of effort she had put into the festival, to have her group climax the event with such a bungled, unrehearsed performance made her weep uncontrollably. As she cried, she realized something

else was bothering her, that she was, in fact, pregnant. Nine months later, her daughter Chynna was born.

Backstage in the Quonset hut behind the arena, Jimi Hendrix handed Gary Duncan of Quicksilver a silver pill box filled with purple tabs. Duncan took one, and Hendrix gulped a couple more himself. Soon the room was throbbing with music as Hendrix picked up an electric bass and matched lines with Jack Casady of the Jefferson Airplane, also playing electric bass. Over at the Home Ec building on the fairgrounds, members of the Grateful Dead joined some of the other members of the Airplane and Hendrix's band in a post-fest jam session.

The partying went on all night at the Highlands Inn, where most of the festival performers were staying. Pete Townshend found another guitar, and The Who kept it up into the wee hours on the back of a flatbed truck.

In the euphoria and confusion attending the end of the event, the Fender amplifiers Adler had borrowed from a Monterey music store disappeared. Somehow these same amplifiers turned up the next weekend at a free concert in San Francisco's Golden Gate Park and were stored in the back of the Free Store on Haight Street. Eventually, a letter from the festival management arrived asking the Grateful Dead—for some reason—if the group had any information on the whereabouts of the missing equipment. The festival officials were informed by return letter where the equipment could be picked up. "When you come," the note concluded, "be sure and wear some flowers in your hair."

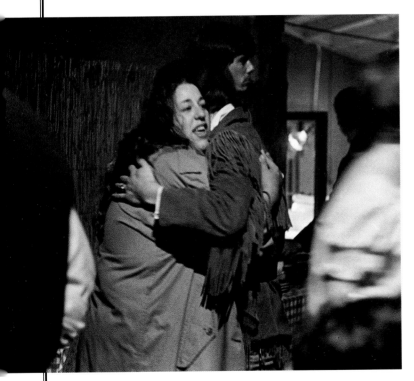

Mama Cass greets a friend backstage.

Afterword

.

FIVE MONTHS AFTER THE FESTIVAL, San Francisco journalist Jann Wenner launched a new music magazine, *Rolling Stone*, with a front-page story on the first issue blasting the festival board: "Where's the Money from Monterey?" According to author Michael Lydon, the festival claimed a net profit at the end of that August of more than $200,000, with only $50,000 allocated to a music instruction program in Harlem that Paul Simon intended to personally oversee. Lydon also noted the board backed off on expressed plans to donate money to the Diggers. He questioned some of the booking policies of the festival, as well as the high expenses, calling the festival "the tradi-

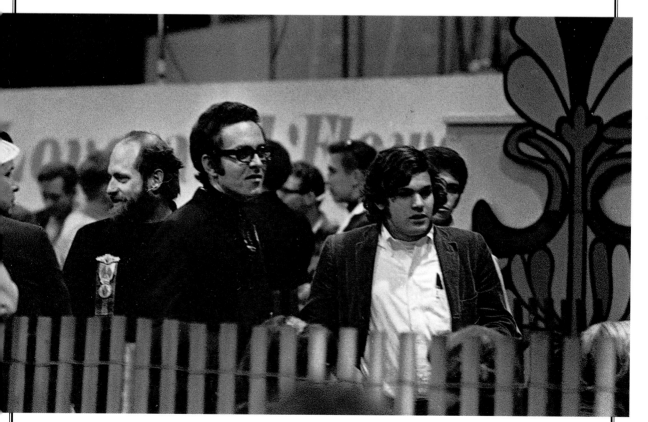

Jann Wenner (far right) of <u>Ramparts</u> magazine in the press enclosure, five months before he founded <u>Rolling Stone</u>.

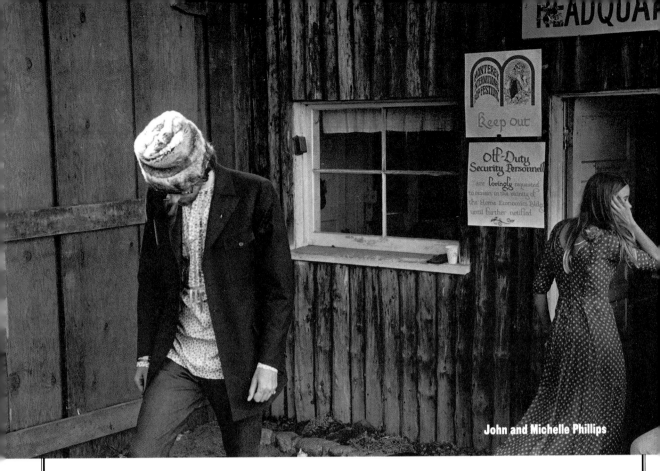

tional Charity Ball in hippie drag."

Ralph Gleason took the board to task in his *Chronicle* column. "Everybody had a ball at the festival," he wrote, "but the delayed reaction is somewhat akin to that of a businessman after a weekend with a gorgeous hooker when he discovers he has VD."

In October, board members met at Phillips' house and considered formal requests from more than thirty organizations, including Paul Simon's guitars-for-the-ghetto program. Press agent Taylor, under pressure to provide answers, took a sarcastic swipe at Lydon in an utterly facetious telegram he sent in reply to questions about the hotel expenses of Johnny Rivers. "The man in whose hotel bill you are interested," Taylor cabled Lydon, "ran up a tab for ninety-three thousand four hundred sixteen dollars which included an endless supply of professional women, narcotics, police bribery, unspeakable fleshy indulgences, psychiatric assistance and lipsynching devices to conceal his incapacity to perform live. Also he had to put a fix on the mayor. . . ."

By the end of the year, the festival's foundation also granted $25,000 to the Sam Cooke Scholarship, a black radio announcers' endowment suggested by Jerry Wexler, but Adler was in no hurry to dispense the funds. The Los Angeles and San Francisco Free Clinics each received a donation of $5,000. An embezzlement accounted for $50,000, $35,000 of which was later recovered. Even Gleason was eventually satisfied.

The TV special deal fell apart a few months later when director D. A. Pennebaker, in a mischievous mood, screened some of the Jimi Hendrix footage for ABC-TV president Tom Moore. Some wild-haired black guy, mumbling ominously and feigning sexual intercourse with his guitar—not on my network, Moore essentially told the festival board.

Ironically, if it hadn't been for the payments ABC-TV had already made, the non profit festival would have actually lost money. Expenses ran slightly less than $300,000, and revenue from ticket sales and other sources barely topped $200,000.

The board decided to release the film as a theatrical feature. But when no major film company expressed interest in distributing the movie, Pennebaker was left with no alternative but to distribute it himself to the so-called art house circuit, which specialized in peripheral markets ranging from foreign films to soft-core pornography. He sketched out a rough edit on the back of a menu at Max's Kansas City, a Manhattan niterie, and entered the cutting room.

He screened at least one rough cut that included songs by the Paul Butterfield Blues Band and Electric Flag. With a lengthy Ravi Shankar raga as the crucial closing segment, the early versions never achieved quite the proper rhythm and ran too long. When Truman Capote, after one of these early screenings, told Pennebaker he should cut the blues numbers, Pennebaker blanched. What the hell do you know? he thought at first, before realizing that if Capote could tell, anybody could. He cut the numbers.

After weighing offers from London and Melbourne, Adler and Phillips took steps toward presenting a second festival, applying for dates at Monterey. In February 1968, the County Fair Board, who run the fairgrounds, granted the dates of June 21–23 by a vote of 7–1. The storm broke immediately.

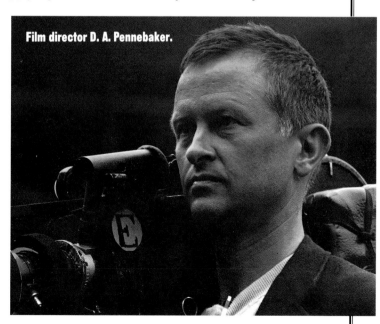
Film director D. A. Pennebaker.

Mayor Minnie Coyle, the affable grandmother so full of praise for promoters on the fairgrounds during the festival weekend, lashed out against having the festival return to Monterey. She claimed the city couldn't handle the housing, the sanitation, or even the everyday retail needs of an influx of 30,000 festival-goers. She also objected to the noise.

Monterey Police Chief Frank Marinello told city authorities that the Pop Festival was so peaceful that not a single arrest had been made and that the annual jazz festival was ten times "more of a powderkeg." Sheriff Jack Davenport, reportedly not even present during the weekend, contradicted Marinello, saying there had been sales of drugs and "open fornication."

Adler and Phillips flew to Monterey to appear before a special five-hour meeting of the County Fair Board. Again, Mayor Coyle spoke out against letting the festival come back. A citizens' committee was appointed to work matters out, but Assemblyman Alan Patee suggested state approval might be neccesary. District fairs come under the jurisdiction of the fairs division of the state Department of Agriculture. "This whole thing has gotten completely out of hand," he said.

At the end of the month, Phillips and Adler returned to Monterey for yet another public meeting. The citizens' committee announced approval, and the Fair Board ratified the agreement subject to several conditions ranging from cash deposits to the rather bizarre requirement that the festival hold on-site religious services. Adler, Phillips, and the city manager thought a contract could be put together within a couple of weeks. But it couldn't. A month later, Adler announced all plans to stage a second festival had been abandoned.

Finally, in December, the D. A. Pennebaker film, *Monterey Pop*, opened in New York. It was slowly made available to the provinces (not reaching San Francisco, for instance, until the following April). Confirming the ascendancy of Jimi Hendrix, Janis Joplin, Otis Redding, The Who, and Ravi Shankar, the film captured the innocent charm of the festival in a way future rock concert documentaries could only imitate. Calling it "one of the truly invaluable artifacts of our era," critic Richard Schickel of *Life* magazine said the film was "a remarkably accurate microcosm of a vibrant but ill-defined area of contemporary culture." The movie eventually earned a $2 million box office gross. However, through his own inexperience and incompetence as a film distributor, Pennebaker carried the movie as a loss on his books for almost fifteen years.

The Mamas and the Papas split up the year after the festival; the group played only one concert after Monterey. Adler went into semi-retirement. Live albums from the Wally Heider tapes of Monterey were issued by Ravi Shankar and the Mamas and the Papas; Jimi Hendrix and Otis Redding issued a joint album. The festival era that Monterey had initiated

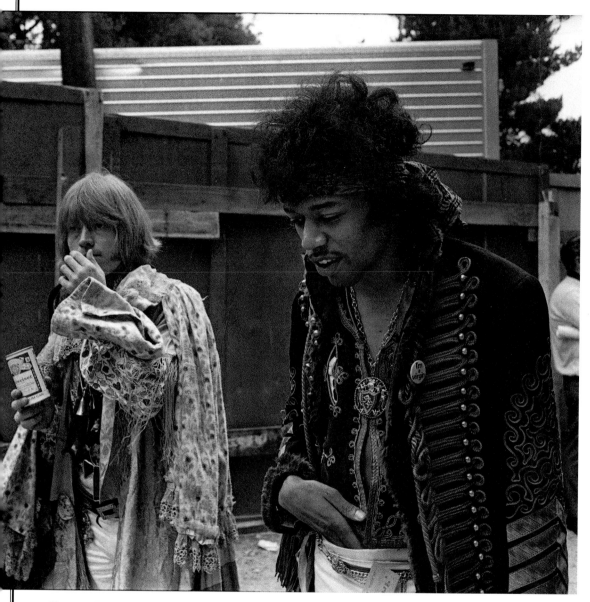

Monterey Purple: Brian Jones and Jimi Hendrix strolling backstage.

grew to previously unimaginable proportions; crowds of nearly half a million attended both Woodstock and Altamont, each also filmed for documentaries.

It was left for Eric Burdon to give voice to people's memories of that June weekend. On his late-1967 single "Monterey," a Top Forty portrait of the festival, he spoke for a number of people who were there: "I think that maybe I'm dreaming," shouted Burdon.

They weren't.

Acknowledgments

· · · · · · · · · · · · · · · · ·

The author gratefully acknowledges the contributions and recollections of Lou Adler, Peter Albin, Elvin Bishop, Hal Blaine, Frank Cook, David Crosby, Ed Denson, Gary Duncan, Barry Feinstein, David Getz, Jean Gleason, Nick Gravenites, Jane Handel, Chet Helms, Booker T. Jones, Paul Kantner, Julius Karpen, Andy Kulberg, Peter Lewis, Country Joe McDonald, Barry Melton, Jerry Miller, Steve Miller, Mark Naftalin, Laura Nyro, Alan Pariser, D. A. Pennebaker, John Phillips, Michelle Phillips, Ron Polte, Danny Rifkin, Grace Slick, Phil Walden, Bob Weir, David Wheeler, and Tom Wilkes.

Accounts of the festival especially useful in compiling this text include writing by Richard Barnes, Eric Burdon, Robert Christgau, David Crosby and Carl Gottlieb, Mike Dougherty, Nicholas Fitzgerald, Myra Friedman, Stephen Gaines, Ralph J. Gleason, Barry Hansen, David Henderson, Patrick Humphries, Robert and Jonalee Hurwitt, Blair Jackson, Pete Johnson, Eileen Kaufman, Al Kooper and Ben Edmonds, Michael Lydon, Dave Marsh, Mitch Mitchell with John Platt, John Phillips with Jim Jerome, Michelle Phillips, John Rogan, Barbara Rowes, Ellen Sander, Robert Santelli, Judith Sims, Irwin Stambler, Derek Taylor, Dave Zimmer, and others.

Research assistance by Nick Meriwether.

Special thanks to Art Fein, Dennis McNally, Phil Elwood, Harry Sumrall, Charitable Trusts Registry of the California State Attorney General's office, the Monterey Pop Festival Foundation, the *San Francisco Chronicle*, and to Jim Marshall for the inspiration and impetus. Jim Marshall thanks Eric Lefcowitz for his help with the project. Thanks also to Nion McEvoy and Charlotte Stone of Chronicle Books and agent extraordinaire Frank Weimann of the Literary Group. And, as always, to Keta and Carla for the love, patience, and lessons in life.